23.11.23

Extraordinary Mothers & Daughters

Extraordinary Mothers & Daughters

Stories of Ambition, Resilience, and Unstoppable Love

BY

EMILY FREIDENRICH

ILLUSTRATIONS BY

NATASHA CUNNINGHAM

CHRONICLE BOOKS
SAN FRANCISCO

For my Ma

Library of Congress Cataloging-in-Publication Data:
Names: Freidenrich, Emily, author. | Cunningham, Natasha, illustrator.
Title: Remarkable mothers, extraordinary daughters : twenty-seven stories from Diana Ross and Tracee Ellis Ross, to Ingrid Bergman and Isabella Rossellini / by Emily Freidenrich ; illustrations by Natasha Cunningham.
Description: San Francisco : Chronicle Books, [2022] | Includes bibliographical references.
Identifiers: LCCN 2021031514 | ISBN 9781797210667 (hardcover)
Subjects: LCSH: Mothers and daughters. | Celebrities—Family relationships.
Classification: LCC HQ755.85 .F756 2022 | DDC 306.874/3—dc23
LC record available at https://lccn.loc.gov/2021031514

Manufactured in China.

Illustrations by Natasha Cunningham.
Cover lettering by Selina Saldívar.
Design by Allison Weiner and Angie Kang.
Typesetting by Howie Severson.

10 9 8 7 6 5 4 3 2 1

Chronicle books and gifts are available at special quantity discounts to corporations, professional associations, literacy programs, and other organizations. For details and discount information, please contact our premiums department at corporatesales@chroniclebooks.com or at 1-800-759-0190.

Chronicle Books LLC
680 Second Street
San Francisco, California 94107
www.chroniclebooks.com

Contents

Introduction

The relationships between mothers and daughters can take many forms.

They can be a relationship of mentorship or friendship or admiration. One of hardship and trauma, of caring and love. No relationship is perfect; no two are alike. They are not static things, but always changing and growing with us. These relationships expand, as new generations join the fold. But they don't contract when other generations leave us—we still hold space for those who've gone. We honor them by passing along our mothers' lessons to our daughters, and every day our daughters also teach us too.

This book explores twenty-five stories from well-known mothers and daughters. It's a collection of moments in which we might find something familiar to our own experience.

Our mothers might make paths for us to tread, as superstar Diana Ross led her talented daughter, Tracee Ellis Ross. Our mothers might leave us with lessons that carry us forward when they're gone, like the one playwright Phoebe Ephron bestowed on her iconic writer-director daughter Nora Ephron and her three sisters. Some of us might find our best friend or biggest fan in our mothers or our daughters, like tennis phenoms Venus and Serena Williams always have in their mom, Oracene Price.

Our daughters sometimes have to define their own way—Judy Garland was a sparkling film icon, but daughter Liza Minelli worked hard to carve a brilliant path of her own. Deepening our connection with our mothers and daughters can also take work, as Jada Pinkett Smith and Willow Smith shared on their web show, but it can be well worth the effort. And for those who know they can count on each other to be there when we need them most, like May May Miller (Ci Zhang) and her daughter, Chanel Miller, there will always be light in the darkest moments.

Whatever motherhood and daughterhood look like, at the end of the day, the women in this book prove that these are our relationships to make, to shape, and to build—together.

Chapter 1

Like Mother, Like Daughter

Following in her footsteps and in her embrace

Diana Ross &
Tracee Ellis Ross

Alice Waters &
Fanny Singer

Lisa Bonet &
Zoë Kravitz

Audrey Hepburn &
Emma Kathleen
Hepburn Ferrer

Betye Saar, Alison Saar
& Lezley Saar

Our mothers often imagined we would always do as they do, as parents and adults, in our relationships and our careers, and in how we move through the world. We might be extending that same idea, whether we realize it or not, to our children—especially our daughters.

For some of us, the path our mother carved fits the contours of our body and our heart, even as we reshape and mold it to better suit our journey.

Tracee Ellis Ross has often said that she grew up in her superstar mother's embrace, not her shadow. As Tracee ventured into modeling and acting, she always felt supported and loved.

So too did actress Zoë Kravitz as she took on an especially poignant role. As the lead in the 2020 remake of High Fidelity, *she uncannily mirrored her lookalike mother, Lisa Bonet, who played a past love interest of John Cusack in the 2000 film.*

For food writer Fanny Singer, her most vivid memories growing up as the daughter of legendary restaurateur and chef Alice Waters include cooking as ritual and eating as experience—she knew she'd always experience the best of life through food.

Hollywood icon Audrey Hepburn was living her most fulfilled life before her untimely passing. Today, Audrey's life lessons wrap around her lookalike granddaughter Emma Kathleen Hepburn Ferrer as warmly as Audrey's passed-down sweaters.

And while Betye Saar has been an artist/soothsayer for over five decades, her daughters Alison and Lezley have built on their mom's visual language to continue that conversation.

IN HER FOOTSTEPS
AND IN HER EMBRACE

Diana Ross & Tracee Ellis Ross

Tracee Ellis Ross is pretty sure she has the best mom of all time. "I had an extraordinary role model in my mother," she told *Good Housekeeping* in 2017. "She supported me in moments of disappointment and supposed failure from a standpoint of empowerment, not victimhood. . . . Partly because of that, I was able to design the life I wanted to have and feel empowered to be the woman I want to be."

She's talking, of course, about the woman; the legend; the record-setting, Golden Globe–winning, Oscar-nominated, Presidential Medal of Freedom recipient; superstar singer Diana Ross.

The Supremes front woman first made her mark with "Where Did Our Love Go?" The girl group went on to release a record-setting twelve number one hit singles on the Billboard Hot 100 chart, including "Baby Love" and "Come See about Me." Diana's solo career debuted in 1970 with her self-titled album featuring the chart-topping "Ain't No Mountain High Enough." The single "I'm Coming Out," from her subsequent album, also skyrocketed to number one in the United States. With her regal beauty, gorgeous voice, and iconic hair, the big screen wasn't far behind—Diana starred and sang in the 1972 Billie Holiday biopic, *Lady Sings the Blues*, and played rising model Tracy in *Mahogany* in 1975.

But daughter Tracee says that even in her lofty fame, her mom was always just her mom. "Whether she was about to go onstage or busy having a meeting, she never responded with, 'Not now, I don't have time.'" The singer saw her kids home after

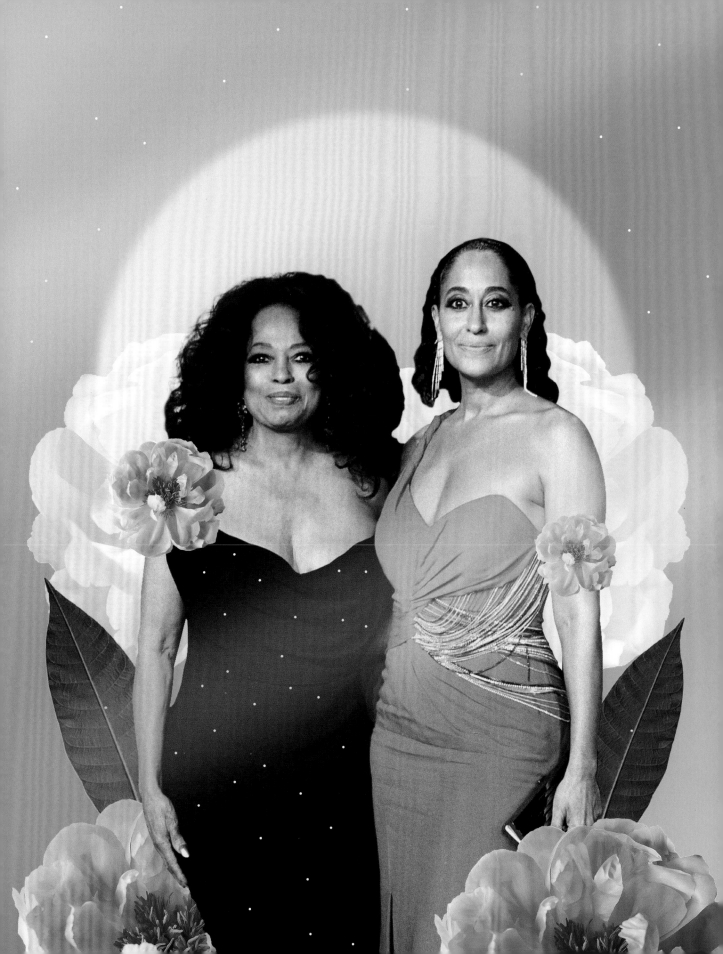

school; she even helped them pack for college. "I felt like I grew up in her embrace, not her shadow. [Her children] were always more important than fame," Tracee said. She is the third of Diana Ross's five children, and her dad is music exec Robert Ellis Silberstein. After college, Tracee first launched herself with a modeling career among the supermodels of the 1980s and '90s, walking the runway for Thierry Mugler at Paris Fashion Week.

"I got to have the example of my parent really being her full self. It's given me a lot in my life," she told *W* magazine in 2014. As Tracee sees it, her mother lived out her own dreams—she didn't need to live them through her children. "She really gave us space and the courage to live the lives that we want to be living," she said. "I could really curate or design the world I wanted to be living in. [I had the confidence] to say, 'Does that work for me? Is that something I want?'"

Tracee moved into acting in 1996, taking roles in indie films and made-for-TV movies until her breakout role in the TV show *Girlfriends*, which ran for eight years. Today, she is known best as Dr. Rainbow Johnson on the NBC hit *Black-ish*. "Lately, I feel like I'm telling the same story through everything I do; about what it is to be a black woman and all the joy, the beauty, the power, and other facets that come with that," she said.

In a full-circle moment in 2019, she took the role of a superstar singer approaching middle age in the film *The High Note*—for which she got to sing. "Honestly, it was a childhood dream of mine, and my mom knew I could sing. Every ten years or so, she would make a little comment like, 'It's time to record now, don't you think?'" Tracee told the *Sydney Morning Herald* in 2019 that she'd brushed off her mom's nudges for a long time, perhaps daunted by the comparisons with such an extraordinary singer for a mother. "I guess I was just waiting until this perfect project helped me walk into that dream again."

The film was released to many glowing reviews, but one was particularly important: "She loved it," Tracee said. Her mother watched the film on the day it was released for streaming, and she gushed to her daughter immediately. "And when she heard me sing she said, 'Finally!'" And even though Tracee had tried not to emulate her mom in the role, sometimes blood just wins: "There was one song I recorded that I thought to myself, 'Oh, my goodness, the tone in my voice. I sound so much like my mom.'"

THE WONDERS OF COMING HOME

Alice Waters & Fanny Singer

Food writer and author Fanny Singer is happiest writing at her mother's kitchen hearth in Berkeley. There is always a big fire to chase the chill of Northern California's foggy days, and there is always a fried egg or some other delicious food to cook together and share together.

The irony did not escape Fanny that her book—part cookbook, part memoir—titled *Always Home: A Daughter's Recipes and Stories* was released just as California shut down due to COVID-19. Her book tour canceled, she decided to quarantine in the Berkeley home she was raised in, with her mother, the world-renowned restaurateur, chef, food writer, and activist Alice Waters. Her mother penned the book's foreword and also intended to join the tour to promote the book. But perhaps it was more

fitting, in the end, that the duo conducted their virtual book tour together from home, in front of the very kitchen hearth that is so central for Fanny.

"I very quickly understood there was no way for me—as Alice Waters's daughter—to exist in the public eye without acknowledging and writing that," she told *The Fold* magazine in 2020 on choosing to frame her memoir around her mom. "Rather than feel encumbered by it, how can I talk about all the wonders of this relationship?"

The book recounts in Fanny's poetic language the colorful, aromatic world of her upbringing. Sixty recipes are interwoven with small stories, sometimes a memory begetting a recipe, sometimes the other way around. To Fanny, there is no real way to extricate her lived experience from

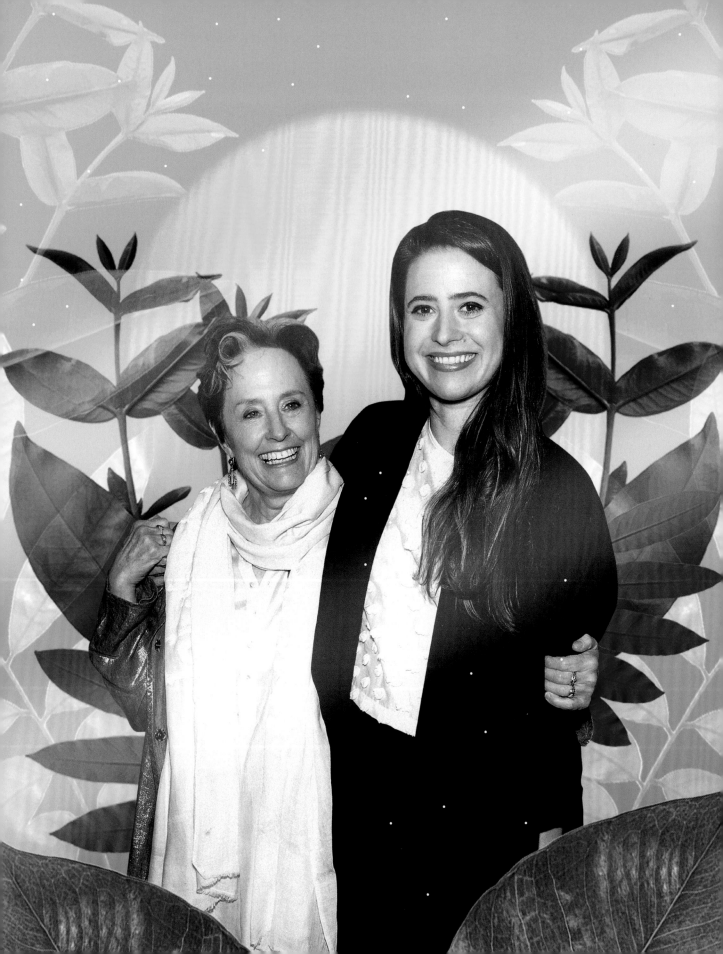

the food-centric world she was raised in. As an infant, for example, her cradle was an oversize salad bowl in the kitchen of Chez Panisse, her mother's groundbreaking farm-to-table restaurant in Berkeley. (If that sounds like the start of a picture book, you wouldn't be wrong. Little Fanny was the subject of her mother's children's book *Fanny at Chez Panisse*.) The book's last recipe, Coming Home Pasta, combines pantry aromatics like anchovies and shallot into a comforting go-to pasta dish that Alice always threw together when the family returned from a long trip. "People always ask me how we have such an amazing relationship," Fanny reflected, "and it's because she was constantly telling me that she loved me in [myriad] ways. And I think probably the most essential thing to know as a kid is just unconditional love."

During the COVID-19 lockdown, Fanny and Alice developed a quiet rhythm together. Alice took daily walks in the morning and left fragrant sprigs of flowers and herbs for Fanny as she started her day. They'd make tea in their favorite teabowls; big, luscious salads from their garden for lunch.

"[The COVID-19 lockdown] feels like a moment to redefine how we relate to the things that we consume," Fanny said. "It's kind of a friendly reminder to be aware of what you have access to, and to be a little more engaged in the aspect of what's beyond the kitchen," she told the *Los Angeles Times* in 2020.

Teaching sustainability and increasing the accessibility of fresh food has been a keystone of Alice's career. Her twenty-five-year-and-counting Edible Schoolyard Project provides a curriculum for schools as well as at-home options for students to grow, care for, harvest, and enjoy what a garden can offer. Alice's use of her platform toward promoting a greater good is ultimately where Fanny aspires to be most like her mom: "I think . . . the type of celebrity I was nurtured by or had proximity to was one that was really premised on, more than anything, my mom's altruism and her desire to affect people's lives in a positive way," she told *The Fold*. "I've been unable to imagine wanting any kind of celebrity premised on anything other than that; I only want to have a positive impact."

MAY SHE ALWAYS
BE PROTECTED

Lisa Bonet & Zoë Kravitz

The internet cannot seem to resist listicles of all the times Zoë Kravitz has looked exactly like her mother, the ageless beauty and fashion icon Lisa Bonet.

Zoë inherited her mother's petite frame, high-cheekbone face, and ethereal gaze, and she occasionally wears her hair in long dreads or braids too. Not least of all, she shares her mom's effortlessly cool sartorial skills. Lisa's 1990s rock-and-roll style has transformed to the earthier, flowing style she wears around her California ranch today. Zoë is simultaneously laid-back and glamorous in impeccably tailored Saint Laurent (she is the brand's face) paired with sportswear one day or over sheer chiffon the next. "Fashion is another medium to express yourself," she told *Porter* in 2018. "[It's saying,] this is how I feel today, this is the external representation of what's going on inside."

Street fashion and red-carpet moments aside, social media just about lost its mind over side-by-side stills of Zoë in Hulu's *High Fidelity* remake next to stills of her mom in the original film released two decades prior. The show was a gender-flipped reboot, with Zoë cast in John Cusack's lead role of Rob, the lovelorn, eternally rejected record-store owner. Lisa had played the original Rob's ex, Marie De Salle.

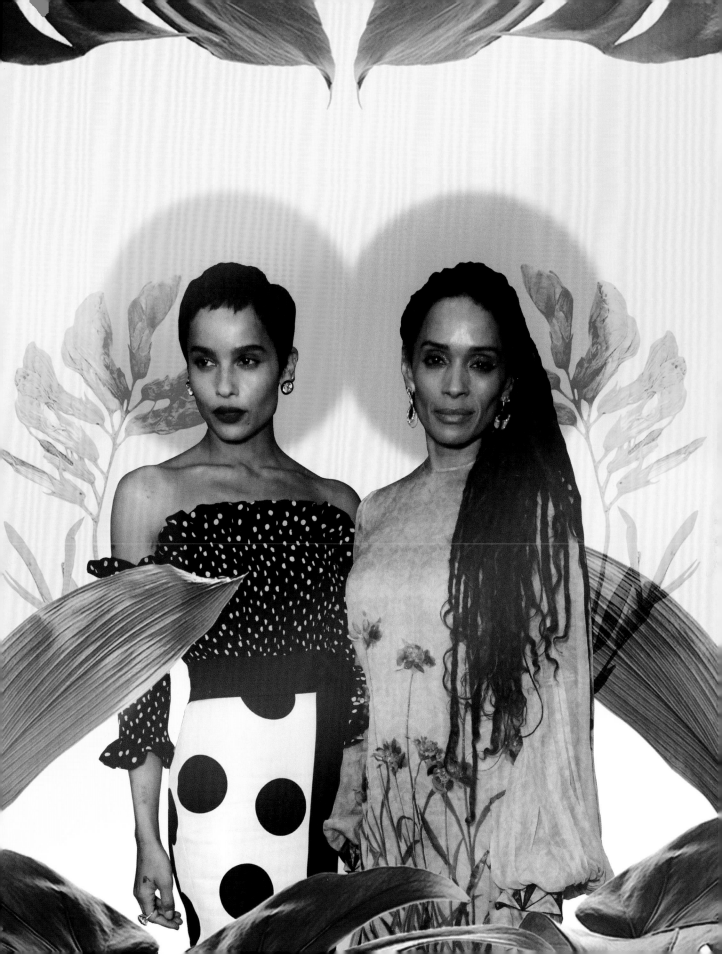

Around the time the 2000 film was released, Lisa reflected to *Honey* magazine that "there were so many things I didn't want to pass on to [Zoë], so I really made a decision to change [into a better person]." The public obsessed over Lisa's whirlwind romance and marriage to rock star Lenny Kravitz, in awe of the couple's shared beauty and enviable cool. She was young, just twenty-one, when she became a mother. "Having Zoë saved my life," she told the magazine; her daughter was a wake-up call to grow up. The couple officially split up when Zoë was five. As much as she could, Lisa tried to shield her daughter from the public drama and the pain she knew too well as the child of a single mom.

Lisa was born in 1967 in San Francisco to a white Jewish schoolteacher and a Black opera singer. Shortly after her birth, her parents broke up, and she was raised by her mom in San Fernando Valley, near Los Angeles. Being a Black child of a white single mom was not a recipe for an easy upbringing: "The world wasn't ready for what I represented [as a biracial child]," says Lisa. She didn't always feel welcome with her mom's family or at school: "I sheltered myself by always withholding a bit, because I didn't always feel safe."

Lisa's experience certainly didn't improve as a young Black woman in show business, even as she played America's big sister, Denise Huxtable, on *The Cosby Show* from 1984 until 1991. Viewers watched Denise grow up from a child to a teenager on *Cosby*, and followed her to college in the spinoff, *A Different World*. Denise is often cited as inspiration to a whole generation of young Black people to attend Historically Black Colleges and Universities.

The recent disgrace of the show's patriarch, now a convicted predator, validates a certain darkness Lisa always sensed. Bill Cosby was livid when, at nineteen, she took a role in *Angel Heart* (1987) that included a nude sex scene. "There aren't endless opportunities for women of color, you've probably noticed," she told *Porter* in 2018—a disturbing reality that would inevitably touch her daughter's experiences in the industry.

"When my name is brought up in a casting office, I'm sure the fact that I'm Black comes up in discussions," Zoë affirms. She was told once that she couldn't audition for a part in a superhero franchise because the casting directors weren't "going urban." She did earn the role of Catwoman in DC's Batman saga reboot, but it's a role that Eartha Kitt and Halle Berry each held before her, so casting a Black actress wasn't an unprecedented move. In 2019, Zoë shared that she had read a script in which there were two couples, with one couple written as Black. "When I talked to the directors, they said I should play the wife of the Black guy," she recalled. "It's insane that they still think the Black girl needs to be married to the Black guy, and everyone else is white. Their thinking is so compartmentalized."

The 2020 remake of *High Fidelity* was a step in the right direction, but Zoë is ready to see more—reimagining white spaces and white characters by casting nonwhite actors only goes so far. It's undeniably an important place to start, but Hollywood is far short of its obligation to elevate stories by

and written for Black people, Indigenous people, and other people of color.

Today, Zoë's mom is also mother to Lola Iolani and Nakoa-Wolf, with a loving partner of over a decade, actor Jason Momoa. She's really proud of all her kids and in awe of her eldest: "She's awesome. She's a well-balanced young woman, and so not affected, and deep and funny and thoughtful," she told *Porter*. "For a parent to have a child out in our insane world and not have to worry about her other than the general 'May she always be protected'—in terms of her making decisions for herself, I feel completely at ease with that, and that's such a great thing."

WHAT MAKES YOU HAPPY, MAKES YOU BEAUTIFUL

Audrey Hepburn & Emma Kathleen Hepburn Ferrer

"I remember thinking that she looked like a friend I wish I could have had," Emma Kathleen Hepburn Ferrer told *Harper's Bazaar* in her 2014 cover story about her grandmother, the late, great Audrey Hepburn. The first time Emma saw her grandmother was in photos of a young Audrey jumping on a trampoline, and she didn't connect that person to the Hollywood icon until years later. "I wish I had met her," she later told *People*. "Every person that met her says she was even lovelier and more radiant than she was in the movies."

Audrey Hepburn passed away in 1993 from a rare form of stomach cancer, about a year before Emma, her first grandchild, was born in Switzerland.

When asked whether he noticed any similarities between his daughter and his mother, film producer and author Sean Hepburn Ferrer mused, "My mother was the same as she was on the screen: unassuming, humble, funny, emotional, strong, delicate. Fortunately, Emma has much better boundaries than either Mom or I ever had. But the genes are strong—and the comedic gene is alive and well." He adds, "And I can't help but think that both had to quit professional ballet because they were too tall."

Audrey Hepburn was born Audrey Kathleen Ruston in Belgium in 1929 to Dutch noblewoman Baroness Ella van Heemstra and British businessman Joseph Victor Anthony Ruston. She was

raised in relative wealth and privilege, and the family's frequent travels across Europe earned Audrey fluency in four languages as a child. Her parents separated just as war was brewing in Europe, and mother and daughter fled to Arnhem in the Netherlands. For five years, they lived, fearful and impoverished, in the German-occupied Dutch city, taking one day at a time to make it through. After the war ended, Audrey pursued ballet in London but shifted to acting when her height prevented her from going further in dance. She acted on the stage and had a few minor film roles before her Oscar-winning performance in *Roman Holiday* in 1953. The rest is Hollywood history.

Her granddaughter spent her childhood in Switzerland before uprooting to Los Angeles, but she attended high school and college in Italy. She too left ballet aspirations behind, making the shift to fine art. Today, she is a painter living in New York, making gestural portraits in watercolor washes and luminous oil layers that are tender and intimate.

But for a time in 2014, Emma got to step into her grandmother's shoes for a cover story in *Harper's Bazaar*. The magazine recreated iconic photos of her late grandmother; the recreations were photographed by Michael Avedon, grandson of legendary photographer Richard Avedon, for whom Audrey was the ultimate muse. The elder Avedon's fascination with Audrey played out in midcentury issues of *Bazaar* and was even fictionalized into a musical romantic comedy, *Funny Face*, in 1957, which is Emma's favorite of her

grandmother's films. In the movie, Fred Astaire played the Avedon-inspired romantic lead, and Audrey played a dour, intellectual bookstore clerk-cum-fashion model. Emma got to recreate several of the scenes from the film in photos for *Bazaar*.

"The most surprising and inspiring thing to learn," Ferrer told the magazine at the time, "was that [Audrey] totally defied the paradigms for beauty for her time. I think that's a powerful message of individualism and self-emancipation for all young women and men around the world." As glamorous as Audrey could be when dressed to the nines in Givenchy, her everyday style was boyish for the time, aimed at practicality. A typical outfit was a men's shirt or a cashmere turtleneck, cigarette pants, and flats—today, it's still undoubtedly classic. Emma inherited several of her grandmother's turtlenecks and wears them all winter long. "What makes you happy, makes you beautiful," Audrey said time and again.

As Emma later told *People*, that is the message from her grandmother that continues to inspire her. Later in her life, Audrey left acting behind to focus on humanitarian efforts through UNICEF, becoming its ambassador. Following in those footsteps herself, Emma says, was never a question: "I was never taught to do charity work. It was ingrained in me, always part of my life." Today, Emma and her dad work with UNICEF and continue other philanthropic commitments that Audrey cherished as her true legacy. Emma cited the story about Audrey that she loves best: Toward the end of her life, the actress was

asked by *American Photo* magazine to choose her favorite photograph of herself for their feature of celebrity-curated portraits of themselves. She chose a photograph by John Isaacs (a photographer for the United Nations and *National Geographic*) of herself with a child during a mission for UNICEF. When asked if she wanted the wrinkles on her face photoshopped out, she strongly objected: She had *earned* every wrinkle—and they were not to be removed.

FOLLOWING
THE
PATHFINDER

Betye Saar, Alison Saar & Lezley Saar

In the fall of 2019, ninety-three-year-old Betye Saar had simultaneous solo shows of her work at the Museum of Modern Art in New York and the Los Angeles County Museum of Art in California. It was the recognition she more than deserved after a fifty-something-year career. "It's about time!" Betye said to the *New York Times* ahead of the openings, but as she told *Frieze* in 2016, she's always had a steady faith that "the best things will come to you; you can try to force things, but it won't happen or it won't be as good as you think it will."

Betye came late to art making; she was in her thirties, raising her three daughters, when she took a printmaking workshop—and it clicked. She knew she needed to be an artist. In her practice ever since, Betye has let her intuition guide her. She told *Frieze* that she recalled being clairvoyant as a young child, "but I still have a sort of psychic intuition and, now that I'm older, when I see something that I know is going to be art, then I get it. It's known as 'mother-wit' . . . my intuition."

Betye Irene Saar, née Brown, was born in 1926, in the Watts neighborhood of Los Angeles, the eldest of three children of mixed African American, Irish, and Native American descent. After Betye's father died when she was five, the

family moved to Pasadena. But the siblings would visit their paternal grandmother back in Watts, and it was on those visits that Betye learned the lesson at the core of her art practice. Young Betye was in awe of outsider-artist and Italian immigrant Simon Rodia's iconic Watts Towers—he assembled scrap metal, broken mirrors, seashells, tiles, and more into the seventeen sculptural structures built from 1921 until 1954. "You can make art out of *anything*," she told the *New York Times* in 2019. Or, as she told the *Los Angeles Times* in 2006 about Watts Towers, "You can make art out of nothing."

The seeds of her later work were sown. Works on paper were the gateway to her artistic career, but it was discovering Joseph Cornell's assemblage boxes (which use found objects and mixed media) in 1967 that stirred the internalized lesson from Watts Towers all those years ago, that "anything" and "nothing" could be art. "It was like putting a whole little world in a small container," she said in 2006. Soon she enlisted her young daughters to help her mine Los Angeles–area flea markets, thrift stores, and estate sales for vintage objects, old photographs, discarded household products, and other castoffs or remnants that intrigued her. Sometimes using found frames or upcycled scrap materials for her shadow-box containers, Betye put her found objects together with family items into tableaus that told complex and layered stories. More often than not, they were personal narratives interwoven with the traumatic history and vicious reality of the African American experience.

In *The Liberation of Aunt Jemima*, a standout assemblage from 1972, Betye reimagined a Jim Crow–era plastic Aunt Jemima figurine (an offensive "mammy" caricature-turned-commercial brand). The figurine was originally meant to hold a kitchen notepad, but Betye used it to encase a Black Power fist; it still grips a pencil shaped like a broom in one hand, but Betye added a rifle to the other hand. The work brought Betye national recognition and became a potent visual for Black feminism. Political activist Angela Davis called it "the spark that fired the Black women's revolution."

Today, Betye's daughters Lezley and Alison are both working artists; their sister, Tracye, has found her way as a writer. Her artist daughters call Betye the "pathfinder." She forged the visual language they share, mixing art forms and unconventional media. For the Saar women, it's a means of exploring one's internal life and processing external experiences. But each has taken a branch of Betye's path in her own direction: "Coming from the same environment, we've had similar experiences," Alison told the *Los Angeles Times* in 2006, "but how diversely those experiences can be interpreted, how varied those directions can be—seeing [our] works side by side, you can see the differences." Explains Betye: "I've often said that Alison is the sculptor, Lezley is the painter, and I'm the object maker."

Lezley grew up wrestling with the two sides of her cultural and racial inheritance—a Black mom of mixed heritage; and a white father of German, English, and Scottish descent. Her mixed-media painting *Me, Myself and Identity Crisis* (1998) uses a

cutout book to contain two mirrored and con-
joined female figures, one Black and one white,
floating, like dreamy Faith Ringgold figures, above
a beach.

Alison's carved wooden sculpture *Kitchen
Amazon* (2019) shows an African-art-inspired female
figure wearing a belt of hanging pans. One hand
holds a spoon, and the other balances a pan on her
shoulder. Alison's work also draws on family—in
this case, a kind of hearth guardian figure. She
has warm memories of the "wonderfully chaotic"
kitchen of the Saar childhood home in Laurel
Canyon, California, where her mother would paint
and work on her assemblages, the kids did their
homework, and they all pitched in to prepare meals.

In 2006, the three women came together
for a joint show entitled "Family Legacies: The
Art of Betye, Lezley, and Alison Saar," at the
Pasadena Museum of California Art (now called
the Norton Simon Museum). It featured deeply
emotional and personal works from each artist,
including a tender collaborative piece honoring
the Saar daughters' father, Richard Saar, who
passed away in 2005. Betye reflected that, by
always following her mother-wit in her art mak-
ing, as opposed to being guided by monetary gain,
her role as "pathfinder" has perhaps guided her
daughters to make art that always means some-
thing to *them.*

Chapter 2

Carry This with You

Mementos, lessons, and guiding principles from our mothers

Minnie Riperton &
Maya Rudolph

Ingrid Bergman &
Isabella Rossellini

Phoebe Ephron & Nora
Ephron (with Delia,
Hallie & Amy Ephron)

Thérèse Dion &
Celine Dion

*S*ometimes, our mother leaves us long before we're ready. No matter our age, no matter the reason, the loss is keenly felt, leaving a mom-shaped space in our life.

Without our mother, we can hold close the things she left behind. These things could be tangible: treasured objects, pieces of clothing, books she loved, letters, or diary entries; her likeness in photographs; her gestures and way of speaking captured on film or voice recording; even our own face in the mirror. And there might be other things, less tangible: stories she told us, lessons she gave us of how to love, moments she showed strength in the face of loss or adversity. These things give us comfort when we are ill at ease or miss her the most. They let us connect with a woman we might never have really gotten to know. They give us an answer when we ask or a template for connecting with our own daughters.

The women in this chapter all carry such things that reverberate with the memory of their mothers.

Comedian Maya Rudolph finds that music helps her feel closer to her mother, the late Minnie Riperton—especially Minnie's biggest hit, with its touching origin.

Actress and artist Isabella Rossellini has always taken her mother's lessons in practicality, and what it truly means to be elegant, to heart.

The late writer Nora Ephron and her literary sisters had no choice but to grow thick skin early on, and learned from mom Phoebe Ephron how to turn life into stories.

And, Celine Dion's beloved maman, *Thérèse Dion, saw to it that her talented daughter had the keys to megastardom—starting with her very first song.*

SHE WAS
THIS ANGEL

Minnie Riperton & Maya Rudolph

One thing Maya Rudolph carries is a hit song—
a song that is, at its heart, her mother's original
message of love to her children. "Lovin' You" was
arguably R & B singer and songwriter Minnie
Riperton's biggest hit, and it's how many remember
her today. "I always had a sense that my mom was
doing something different and special, because I
saw how people responded to her," Maya has said.
She connects with the mother she lost through this
song and by making her own music.

To Maya's fans, her musical roots make a lot of
sense. In her roles in film and TV and in her eight
years on *Saturday Night Live*, her beloved comedy
style often features musical numbers and spot-on
but warm impersonations of divas like Beyoncé and
Donatella Versace. She also plays in a two-woman

Prince cover band called Princess with her friend
Gretchen Lieberum.

Music, she says, was all around her as a child.
She has strong memories of her song-filled child-
hood in the 1970s. In addition to her mother and
father (musician and producer Richard Rudolph),
talented friends like Stevie Wonder were always
coming and going. Maya and her brother even
joined their parents on tour when Minnie's career
took off after her mellifluous "Lovin' You" hit
number one on the Billboard Hot 100 list. But it
wasn't until Maya was an adult that she learned the
true origin of her mother's iconic song: It started
as a lullaby.

"She originally wrote that song for me and my
brother," Maya explained in 2019. Her father had

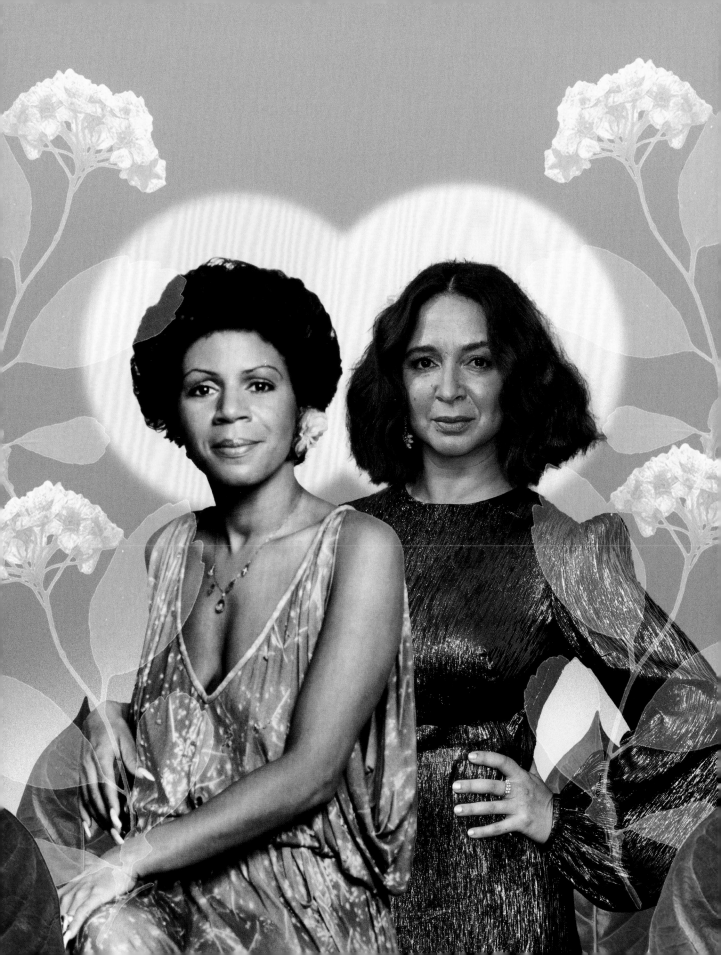

recently told her that Minnie came up with the melody back when the young family was living in Gainesville, Florida. Back then, it was a tune that Minnie would croon to her babies. The song eventually turned into the romantic R & B classic, but at the end of the LP, you can still hear Minnie croon, "Maya, Maya, Maya."

A soul soprano, Minnie's five-and-a-half-octave vocal range is fully on display in "Lovin' You." Growing up as a young singer in Chicago, the "Queen of the Whistle Register" trained at the prestigious Chicago Junior Lyric Opera. Despite her classical training, Minnie was drawn to perform soul, the blues, and rock and roll. At fifteen, she left opera behind for her first band, a girl group called the Gems. She later sang backup for greats like Etta James and the Dells (of "Oh, What a Night" fame) and performed with psychedelic soul and R & B bands before testing the waters as a recording artist.

But by 1973, according to Maya, her mother had nearly given up on a musical career. Her solo debut, *Come to My Garden* (GRT Records, 1970), was commercially unsuccessful, although the album is considered a classic by music critics today. She focused instead on her personal life: She married Richard just three years after the 1967 Supreme Court ruling in *Loving v. Virginia*, which had declared state laws criminalizing interracial marriage to be unconstitutional. Facing racism in Chicago, they decided to leave the city. The couple, with Maya's older brother, Marc, in tow, visited friends in several cities before they settled into a quieter "hippie" life in Gainesville. This story, of course, served as inspiration for Maya's tender

indie romance, *Away We Go* (2009), in which Maya plays a pregnant woman who, alongside John Krasinski as her partner, undertakes a similar road trip to find the right home to raise their baby. They settle in the Florida Panhandle.

Back in Maya's childhood home in Gainesville, she was barely two when a college intern from Epic Records convinced the then-twenty-seven-year-old Minnie to take another shot at singing.

Things moved pretty quickly after that. The family picked up and left for Los Angeles, where Minnie recorded *Perfect Angel*; Richard coproduced the album with Stevie Wonder, who did the arrangements with his band, Wonderlove. Come that August, Minnie kicked off the album's release with an electrifying set at LA's iconic Troubadour club. The album's cover art is a photo of Minnie in overalls smiling adorably over a melting ice cream cone, an iconic image in R & B musical history.

"Lovin' You" almost wasn't released as a single. Initially, the record company didn't see the magic in it—to Epic, Minnie was a Black singer, which at the time meant that a song with no drums or base wouldn't work, her daughter says. But Stevie Wonder wanted to recreate Minnie singing in her backyard in Gainesville: The focus would be her voice, with Richard on acoustic guitar and birdsong in the background (which Minnie captured at UCLA's Botanical Garden with a tape recorder). As Richard tells it, the shift occurred when they were on tour for *Perfect Angel* in Seattle one snowy night. People had filled the audience despite the freezing weather. "When we started to play 'Lovin' You,' we saw this amazing thing," he said in 2019. "People

started moving closer . . . and putting their arms around each other. It was [transformational,] and Minnie looked back at me and I looked at her and asked, 'Do you see this? This is crazy.'" With that experience, they convinced the record company to release the song, and the rest, of course, is history.

Minnie continued touring and recording music (releasing three more albums) even after she received the grim diagnosis of metastatic breast cancer in January 1976. She became one of the first celebrities to make her cancer diagnosis public, and was applauded by President Jimmy Carter for her work as a spokesperson for the American Cancer Society. She didn't share publicly that her cancer was terminal.

Minnie passed away in 1979, just two weeks before Maya was to turn seven. Minnie was thirty-one years old.

After her mother died, Maya has said, people sought her out to tell her how much her mother's music, and her voice, meant to them. Often it was intense, emotional, and uncomfortable: "Complete strangers would just be like: 'I felt like she was this angel!' And you're like: 'I'm sixteen. Why are you telling me about my dead mother?'"

This experience of feeling like a beacon for the grief of her mother's fans and industry friends (a strange kind of fame) has perhaps influenced Maya's attitude as a famous parent herself. Now in her forties, she leads a quiet and private homelife with partner Paul Thomas Anderson. They have four children—Pearl Minnie, Lucille, Jack, and Minnie Ida—and she is careful that they don't experience the same kind of exposure that she did.

These days, she's stopped by strangers who want to know if she's "that lady" from *SNL* or *Bridesmaids* or TV (her guest role on NBC's *The Good Place* earned her an Emmy nomination). She chalks it up to having a distinctive appearance that's recognizable—her tawny hair, freckles, and round face—but her music-infused comedy certainly makes her memorable and approachable. It's fitting that even Maya's friend and former *SNL* castmate Amy Poehler describes Maya and her work in musical terms: "It's kind of like everybody has a song," she has said, "and I think Maya's song is like a really good popular song that will stand the test of time."

Becoming a mother herself while focusing on music in recent years has given Maya a chance to understand and feel connected to her mother on a deeper level. Thinking about her mom was painful for a long time, she has said in interviews. She doesn't think she was given space to grieve the loss on her own terms. But at this point in her life, she says, "I'm so much older than she was and I've had so much time to process all the information I didn't really want to talk about or think about. But then I grew up, and I take such enormous pride in knowing that she really stands out as this individual, as this one-of-a-kind, gem of a human being, of a recording artist, of a performer, and of a woman." In 2019, the forty-fifth anniversary of *Perfect Angel*, it meant a lot to Maya that Princess played at the same LA venue, the Troubadour, where her mother had once stood.

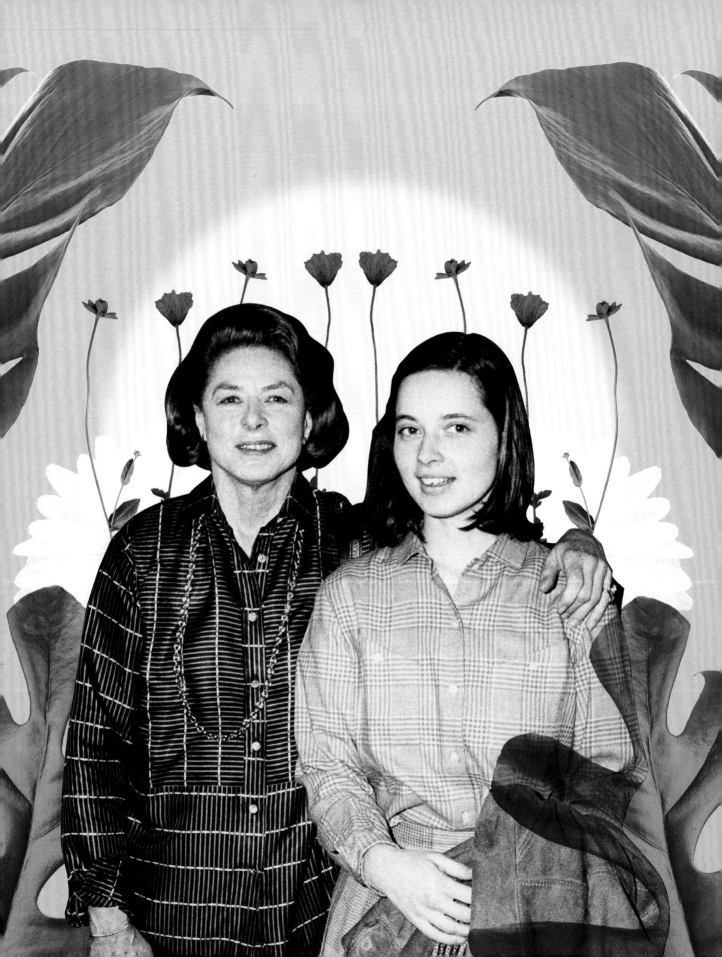

ELEGANCE IS HOW YOU LIVE

Ingrid Bergman & Isabella Rossellini

The things we carry from our mothers might seem small or trivial on the surface, but they are nonetheless etched into our memories from childhood, teenage years, or early adulthood. We might not recognize how formative certain moments were for us until we look back.

Take, for example, the time Isabella Rossellini's mother, Swedish-born film star Ingrid Bergman, told her teen daughter that she didn't need to wear heels on the red carpet or to events if she didn't want to. Some decades later, on the night that *Ingrid Bergman: In Her Own Words* by Stig Björkman premiered at the prestigious Cannes Film Festival in 2015, Isabella wore flats by Stella McCartney with her gown, breaking the unwritten rule that

women must wear heels at Cannes premieres. The ensuing "scandal" was dubbed "Flatgate" by the media. Stories overflowed on social media of women being turned away by festival officials for wearing flats, and men for wearing heels, though the festival's director, Thierry Fremaux, insisted at the time via Twitter that there was no such rule.

To young Isabella, her mother's message was about being yourself in the face of what others might see as an all-powerful force of societal pressure and expectation. But it was also just an example of the truth that Ingrid Bergman lived—designing and making her own clothes, wearing minimal makeup, keeping her family out of the spotlight.

Prior to Ingrid's debut as a silver-screen starlet in 1939, producer David Selznik had famously pushed her to change her name (he worried that Bergman sounded too German in the World War II era) and to get her teeth fixed to look the Hollywood part. She refused: "This is how I look, take it or leave it." He eventually agreed that her "natural" look would make her stand out.

Even Ingrid's iconic *Casablanca* costumes—including the classic wide-brimmed hat and well-tailored suit over a simple blouse in the final scene—aligned with the actress's own taste. Unadorned and understated, it's a look that has withstood the decades. Her focus was always quality, fit, and practicality in the things she wore. Heels hurt her back, so she didn't wear them. But she liked and wore beautiful dresses. No matter what, she held herself like the star she was. "She once created a big scandal," Isabella told the *New York Times* in 2015, "because they asked her what designer clothes she would wear, and she said, 'I seldom wear them, they're so expensive.'"

Ingrid was shunned by Hollywood in 1948 when it came out that she'd become pregnant by Roberto Rossellini, the married director of *Stromboli*. She moved to Italy, wed Roberto, and gave birth to Renato Roberto, followed by Isabella and her twin sister, Ingrid, in 1950. Isabella says she knew her mother was heartbroken by Hollywood's coldness, but Ingrid remained uncowed. She took her love of performance to the stage, starting on London's West End and then moving to Broadway. In 1975, she even earned an

Oscar for her captivating role in *Murder on the Orient Express.* She died in 1982.

Isabella has never been afraid to follow her own path, and she credits her mother for that. "I did resist [acting] for a long time because I thought that I couldn't be as good as my parents or that I was always going to be compared to them," she said in 2020. She started off as a model and eventually began acting in her thirties. Her breakout role as lounge singer Dorothy Vallens in David Lynch's *Blue Velvet* was certainly a controversial debut. She also has a master's degree in biology, which she poured into *Green Porno,* her early-2000s cult series of forty experimental films about the mating lives of insects. Isabella played the insects, with costumes and everything.

In more recent years, she has focused on writing, directing, and spending time with her daughter, Elettra, and her grandchild. "It all evolves," she told *Vogue* in 2018. "I [work in all manner of projects] because I follow my curiosity; the engine at the end is to satisfy curiosity, and then you express what you discover and hope that you find an audience that you can share it with. That has always been more important than being successful."

What her mother told her was always about more than just shoes. "My mother was not a fashion icon; she was still an icon," Isabella has said. "One never has to go through torture to be accepted as one. . . . Elegance is an expression of not only of one's taste but how you want to live your life."

"SOMEDAY YOU WILL THINK THIS IS FUNNY"

*Phoebe Ephron & Nora Ephron
(with Delia, Hallie & Amy Ephron)*

"My religion is 'get over it,'" the late essayist, screenwriter, and director Nora Ephron once told NPR. "I was raised in that religion. That was the religion of my home—my mother saying, 'Everything is copy; everything is material; someday you will think this is funny.'"

Nora might best be remembered today for romantic comedies with female leads who fly across the United States to meet a man they've heard on a late-night radio show (*Sleepless in Seattle*, 1993) or who share a tender email exchange with a stranger who turns out to not be a stranger at all (*You've Got Mail*, 1998). Ultimately, in these New York–centered stories, the type-A, buttoned-up, otherwise cautious heroine (usually Meg Ryan) ends up happily ever after with the charming and clever leading man (often Tom Hanks).

Much of this midcareer work was not obviously based on Nora's life, though autobiographical monologues and moments do seep in. In *When Harry Met Sally . . .* (1989), aspiring journalist Sally's "faceless man" fantasy is actually Nora's; Sally's persnickety ordering habits at NYC diners and her unwavering positivity, which so chafes curmudgeon Harry (Billy Crystal), can be traced to Nora's 1970s *Esquire* essays. After getting her start as a journalist, Nora found her groove with frank and funny disclosures on her looks, insecurities, relationships, and personal fantasies.

Before *Harry Met Sally*, Nora's first adaptation of her life to fiction came with *Heartburn* (1983), a novel based on her very public breakup from her second husband, Carl Bernstein. The subsequent 1986 film, starring Meryl Streep and Jack Nicholson, was at the center of the couple's protracted divorce proceedings. "Writers are cannibals," Nora has said. But she often seemed to find empowerment and a sense of control in making the choice to laugh openly. On *David Letterman*, when the host pointed out the horrible circumstances of Bernstein's cheating on her while she was eight months pregnant, Nora replied honestly: "I think it's funny!" To her, there was comedy gold at the heart of something so Hollywood happening to her.

Turning experiences into words is something that the Ephron women all had in common. Legendary playwright and screenwriter Phoebe Ephron was mother to Nora, screenwriter-novelist Delia, and writers Hallie and Amy. The four Beverly Hills–raised sisters were touted by the *Chicago Tribune* in 2002 as America's own modern-day Brontës. "Everybody started one after the other," Delia told the newspaper at the time. "My sister Nora started writing right out of college. She had the specter of my parents. I had the specter of Nora and my parents. Amy had our example, and Hallie started after that."

Delia cowrote *You've Got Mail* with Nora, who also directed the now-classic rom-com, and the sisters share several other writing credits. The screenplay for Nora's directorial debut, *This Is My Life* (a 1991 critical flop), was cowritten by Nora and Delia based on a Meg Wolitzer novel. It's clear why the story resonated with the sisters: In the novel, the young daughters of a single mother struggle with their mother's emerging career as a stand-up comedian and her constant use of their personal lives as material.

Phoebe and her husband, Henry, wrote a stack of successful films together, notably *Desk Set*, starring Katharine Hepburn and Spencer Tracy; *Carousel*; and *Daddy Long Legs*, starring Fred Astaire. Nothing that happened in the Ephron home was off-limits for a screenplay. Nora even described their family dinner table like a fast-paced writer's room—one girl might make a joke, and their father would immediately demand, "Write that down, that's good!" Nora said Delia once got her head caught in the banister railing and the fire department had to extricate her; some months later, the same scenario appeared in a Jimmy Stewart and Natalie Wood flick.

"Of all the Ephron women, she was surely the most exceptional, for better or worse," Hallie later wrote of their mother. The Ephron daughters have each described their mother's distant relationship with her girls but noted that Phoebe always imparted lessons and templates for their lives through the world of words. "After dinner, she might haul out a poetry anthology and read aloud, as if words were the second dessert," Hallie wrote for *O* magazine in 2013. Hallie added that Phoebe always ensured that their picture books and reading materials featured strong, independent women and girls like Madeleine, Eloise, Dorothy Gale, and especially Valancy Stirling of Lucy Maud Montgomery's 1926 *The Blue Castle*. The ultimate lesson, said Hallie, was that you are only a victim if you want to be—you control your narrative.

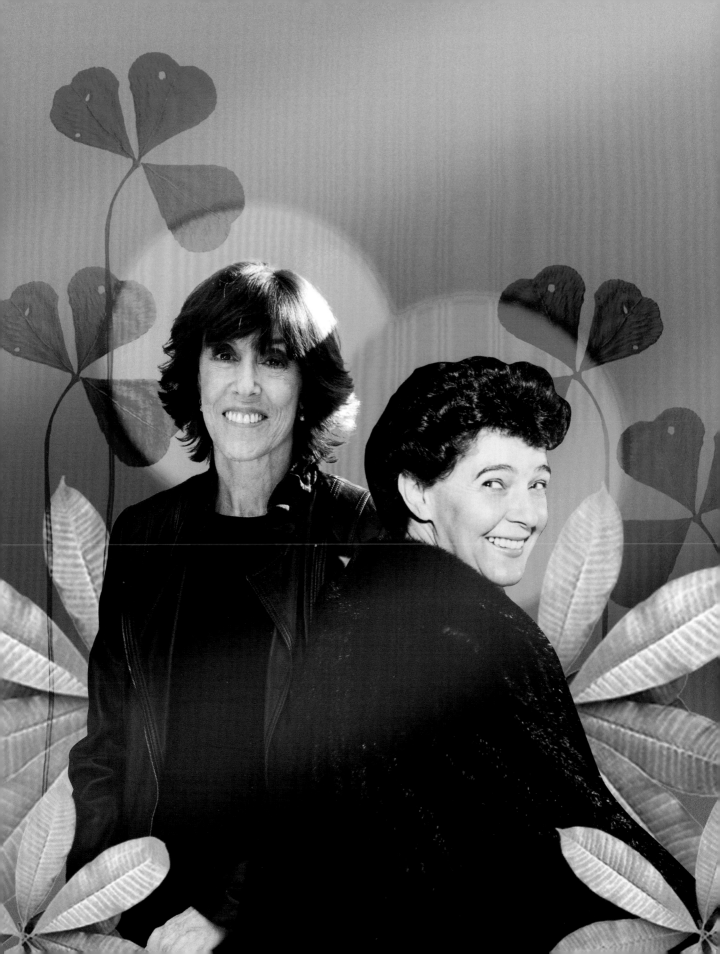

Phoebe Ephron died in 1971 due to cirrhosis of the liver, brought on by decades-long alcoholism. Nora recounted her mother's decline in "The Mink Coat," a 1975 essay for *Esquire*; Amy's first novel, *Cool Shades* (1984), fictionalizes her experience as a teen seeing her mother's descent into addiction, and eventually fleeing her parents' unstable marriage to live alone in New York City at fifteen. Turning life (and death) into copy became the stage on which to process family trauma and to surface ongoing hurt and resentment. After their mother's death, the younger girls cared for their father, also an alcoholic, until his death in 1992. Nora, embracing an exploding career and life in New York, didn't make it to his funeral. Nora's absence from her sisters' lives made it all the more painful for them when she would draw from their experiences for her work. But as sisters tend to know, the game can be played both ways. "You always do this. You take my life, and you use it!" Meg Ryan (the Delia-like character) accuses an indignant Diane Keaton (likely Nora) in Nora and Delia's film adaptation of *Hanging Up* (2000), Delia's book based on the Ephron sisters.

Toward the end of her life, Nora revisited the essay format to great acclaim. Essays like "I Feel Bad about My Neck," which was turned into a successful book (2006), were a place to talk freely about her looks, lessons learned, love of food, and fantasies as an older woman. Was she wiser? Maybe or maybe not, Nora admitted. But she was always witty, always funny, and honest—to a point. In the end, not everything was material to Nora after all; in her final months and days, she did not share, even to close friends, her leukemia diagnosis nor the severity of her illness. Her death in 2012 was a shock to many who loved her. Nonetheless, Nora leaves behind a reputation as a forthright writer and feminist icon; her inherited knack for candor was her most beloved and memorable trait.

WRITTEN IN THE STARS

Thérèse Dion & Celine Dion

When Thérèse Dion died in January 2020, fans across Canada mourned her—one woman tearfully told a Montreal radio station, "It's like we've lost our own mother."

The host of cooking show *Maman Dion* on Quebec TV station TVA from 1999 until 2002 earned her spot after appearing on a local talk show to promote her line of meat pies—and to talk a little about her über-famous daughter, the great Celine Dion. The seventy-one-year-old's funny quips and bossy personality delighted the audience and the network's producers. Though she left the show after just three years, in 2005 she established Fondation Maman Dion, continuing her mothering efforts through its mission to "foster the fulfillment,

the development of self-esteem, and the desire to succeed in school for young Quebecers between the ages of 5 and 16 who come from disadvantaged backgrounds."

"My mother was an amazing woman," Celine Dion said after her mother's death. "We didn't have any money growing up, but our house was rich with love and affection." Celine's origin story reads rather like a fairy tale: In the small French-Canadian town of Charlemagne, Quebec, near Ontario, lived Thérèse Dion and her husband, Adhémar, and their fourteen children. The youngest was a daughter, born in 1968, who they named Celine Marie Claudette. When the girl turned eleven, she was gifted a violin and often sang,

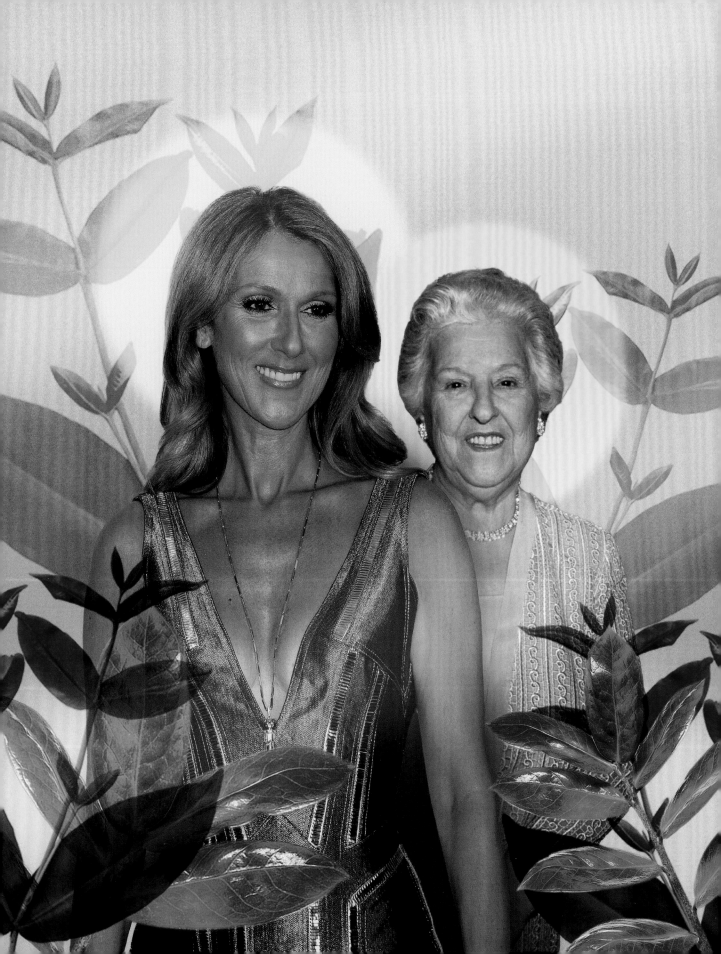

beautifully, in accompaniment. Thérèse knew there was great talent in her youngest and resolved to help her fulfill her potential.

None of her success would have happened, Celine has said, without her mother's insisting that the twelve-year-old record her own song to showcase her talent. When Thérèse couldn't find a songwriter willing to help, she wrote the lyrics herself and enlisted son Jacques for the music. The result was "Ce n'était qu'un rêve" ("It Was Only a Dream").

Thérèse also wanted whoever was managing Ginette Reno, a gold- and platinum-selling Canadian singer, to manage her daughter's career. That turned out to be Quebec-based record label manager René Angélil. When he heard Celine's voice on the cassette the Dions mailed to him, he later said it moved him to tears. In that song, he heard what Thérèse knew—this girl was going to be big. He became her manager and even mortgaged his house to fund her first album, the 1981 French-language *La voix du bon Dieu* (*The Good Lord's Voice*).

Thérèse called the shots in her daughter's career early on, but she eventually ceded more to Celine's manager and eventual husband, René. Celine's shift to English-language pop—with chart-toppers like "The Power of Love," "Think Twice," and the Oscar-winning "My Heart Will Go On" from *Titanic* (1994)—solidified her as the megastar Thérèse always dreamed she'd become, and more. Decades later, Celine Dion is counted among the bestselling recording artists of all time, with over 200 million record sales worldwide. The five-time Grammy winner has topped Billboard charts for decades and has received music industry awards in the United States, Canada, Europe, the United Kingdom, Japan, Hungary, South Africa, and elsewhere. She's also a beloved fashion icon and a mom to three boys with her late husband. "Now more than ever do I realize the importance of a mother's role," the star wrote to Thérèse in a Mother's Day Instagram post in 2019. "Not only did you give me life, but you also wrote my destiny."

Chapter 3

Side by Side

Mothers and daughters as peers and costars, best friends and biggest fans

Peggy Lipton &
Rashida Jones

Tina Knowles-Lawson,
Solange Knowles &
Beyoncé Knowles-
Carter

Terri Irwin &
Bindi Irwin

Oracene Price,
Venus Williams &
Serena Williams

*F*acing life's alligator pit alone—however metaphorical or real—is daunting, but what if you could do it with your biggest supporter right beside you the whole time? When that person is also your mom, who has been exactly where you are and who will fight to the end to make sure you get the space you deserve, you are sure to succeed.

Before she died in 2019, Peggy Lipton was far more than Rashida Jones's mother, best friend, and costar—she was a steadying force in Rashida's world. When Rashida's "partner in crime" was diagnosed with cancer, it was Rashida's turn to bring light and calm to her ailing mother.

Superstars Beyoncé and Solange say that there is one common key to their success: their mother, Tina Knowles-Lawson.

No strangers to tragedy, Terri and Bindi Irwin, beloved wife and daughter of late Steve Irwin, are carrying on the Crocodile Hunter's legacy as wildlife conservation activists and TV hosts.

Oracene Price always knew her daughters had power, and she dedicated herself to ensure that Venus and Serena Williams could wield it.

FINDING JOY
WHERE YOU CAN

Peggy Lipton & Rashida Jones

It was the year she filmed *On the Rocks*, the 2020 Sofia Coppola film about a woman reconnecting with her father as her marriage hits a rough patch, that Rashida Jones found herself in personal purgatory. "I had a child," she told the *Guardian*, "and lost my mom in the same period [during filming], and was in very amorphous emotional shape. . . . I didn't know whether I was coming or going."

When a loved one has been battling cancer, for so many of us that feeling of indistinct edges can be pervasive. Treatment and the daily physical, emotional, and mental toll the disease can take on the cancer endurer can be like an anchor to the present moment that gives no sense of duration or ending. Rashida Jones recognized an opportunity for bringing in the light where she could when her

mom, Peggy Lipton, was diagnosed with colorectal cancer in 2002.

"I decided my job was to find joyful moments during what could have been a terrifying time for both of us," Rashida explained in her essay for *O* magazine in 2009. "Just because a situation is grim doesn't mean you don't have every right to smile. It isn't about 'being strong' and pretending everything's okay; it's about finding joy where you can." The scorched-earth approach of chemo is brutal on the body; as Rashida put it, "The goal is pretty much to kill everything in your body without killing you." She wished she could have gone through it for her mom, lifting that burden from her. Instead, she told her mom "dumb jokes"; they laughed together about a well-intentioned

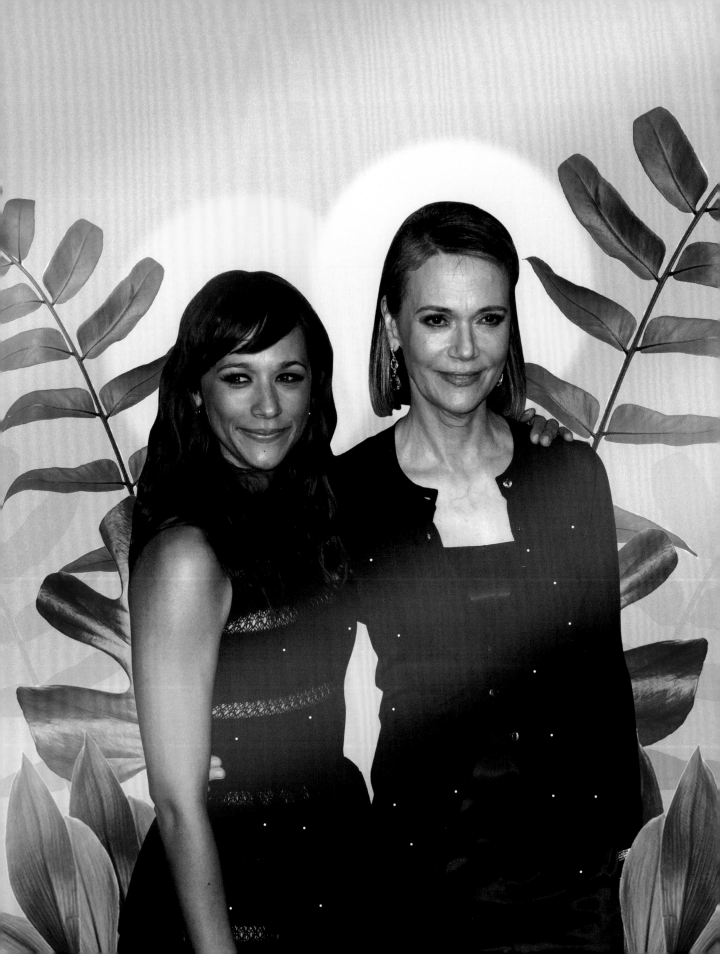

but not-so-good Simon and Garfunkel cover singer playing at her mom's clinic to uplift patients. "That summer all we did was laugh," she said.

Rashida had always considered her mother to be more than a mom—more than a best friend, even. Rashida and her sister, Kidada, are the daughters of 1960s beauty icon and actress Peggy Lipton and legendary music producer Quincy Jones. When the two divorced, Rashida (ten at the time) chose to live with their mom, and Kidada (then twelve) lived with Quincy. "Mom is the most unconditionally loving person I will ever know, and she has always supported me on every level," Rashida wrote in *O*. As she headed toward a Hollywood career, her mother was always by her side: "She worked with me before every audition; she's given me perspective, and she has let me cry."

Peggy knew what it was to find your footing in Hollywood. She began modeling as a teen and very quickly took on TV roles. Her biggest break was *The Mod Squad* as a reformed juvenile delinquent turned (gorgeous) undercover "hippie cop." The show was hugely popular—it was nominated for Emmys and won a Golden Globe—and so was the twenty-one-year-old actress. She struggled with her newfound fame, she told the *Los Angeles Times* in 1993: "[The fame] drove me into my house. I was very paranoid. I didn't like going out. I had no idea how to be comfortable with the press. I was very young. It was really hard for me." She briefly channeled her star power into a short stint as a singer, and that was how she met Quincy.

The two married in 1974, and she stepped back from acting with some level of relief to focus on raising their girls. This was not without its own challenging spotlight and unwanted criticism. In her 2005 memoir, *Breathing Out*, Peggy talks about the racist backlash against their interracial marriage, including from her own mother. Though Quincy and Peggy separated in 1986 and were divorced by 1990, they always remained close.

After her divorce, Peggy knew she wanted to reenter entertainment, but she felt unmoored and without connections, she said in 1993: "I had a push-pull thing inside me that I wanted to do it . . . [but] I had become so insulated in my world as a mother, that I didn't know how to pick up the phone and call anybody to put myself out there." Her break came with David Lynch's TV series *Twin Peaks*. Peggy was cast as Norma Jennings, the willowy owner of the local diner serving up "damn fine coffee" and cherry pie to FBI special agent Dale Cooper (played by Kyle MacLachlan) and the fictional Pacific Northwest lumber town's quirky inhabitants. The original show only aired for two seasons, but it gained enough of a cult following to earn a much-lauded 2017 revival, with Peggy reprising her memorable role.

That same year, she made an appearance in an episode of Rashida's cop-comedy *Angie Tribeca*, playing Peggy Tribeca, the mother of the main character played by her daughter. Rashida has taken film roles but has mainly made her career in television, like her mom before her, both acting and writing. She drew attention as the somewhat scary Karen Scarfolli in an episode of the one-season classic *Freaks and Geeks* (2000) and as another Karen, Karen Filippelli, in *The Office*—she was briefly Jim's flame, then his ex and an on-the-rise Dunder Mifflin manager (go, Karen!).

But she will forever be known for her role as Amy Poehler's BFF in *Parks and Rec*, the beautiful sunfish nurse Ann Perkins.

Angie Tribeca wasn't the first time Rashida and her mom had worked together—the two shared the stage in the 2002 run of *Pitching to the Star*, joined by Robert Lipton, Peggy's brother. "The three of us on the same stage—that was such a special experience for me," Rashida wrote in O. But it was just a few months after the play ended that Peggy was first diagnosed with stage 3 colon cancer, found during a routine colonoscopy. The fifty-six-year-old actress immediately began an aggressive treatment plan of surgery and chemotherapy. She would stave off cancer for almost two decades. She died May 11, 2019; she was seventy-two.

In the fog of her grief, Rashida was still able to find the bright spots. In 2018, before her mom's death, she became mom to a son with partner Ezra Koenig, frontman for Vampire Weekend. "I know that in life there will be sickness, devastation, disappointments, heartache—it's a given," Rashida told O readers. "What's not a given is the way you choose to get through it all. If you look hard enough, you can always find the bright side."

THE ART OF MAKING HISTORY

Tina Knowles-Lawson, Solange Knowles & Beyoncé Knowles-Carter

Tina Knowles-Lawson contains multitudes. She's probably best known as the mother of superstars Beyoncé and Solange. But before that, she was a highly successful salon owner, then a fashion designer; today, she is a skilled entrepreneur, a bestselling author, and a passionate art collector. She's also grandma to granddaughters Blue Ivy and Rumi and grandsons Sir and Daniel Julez. Fans call her simply Miss Tina.

Tina came into the world as Celestine Ann Beyincé in 1954, the youngest of seven children born to Louisiana Creoles living in Galveston, Texas. As a child, everyone called her "Tenie B."

Her mother, a self-taught seamstress, passed those skills on to her daughter. Tina sewed to earn a little money for her family, but she also made the outfits for her all-girl singing group, the Veltones.

She was twenty-six when she married Mathew Knowles and quickly had their two girls. The young family moved to Houston, where Tina first worked as a beautician for cosmetics company Shiseido. But her first major entrepreneurial endeavor was her hair salon, Headliners, which became hugely successful in the city. As her daughters' impressive talents emerged, they had the full range of their

mom's beauty and design arsenal behind them as they pursued the spotlight.

It would be Beyoncé's iconic girl group, Destiny's Child, where Tina's fashion design skills particularly shone. As she did for the Veltones, Tina designed the trio's coordinated red-carpet and performance looks—often daring, midriff-baring, memorable ensembles in materials that never failed to catch the eye. But Tina revealed to W magazine in 2020 that she received pushback from the record company for making the girls look "too Black." "I was told that they should look like Britney Spears and Christina Aguilera," she said. "In order for the girls to cross over, [the record label] said they needed to wear jeans and T-shirts. I took offense to it because I felt like the girls, in their splendor, were different, they were unique, they were unapologetically Black." Tina told the magazine that they didn't change for the record label, and that paid off: "People started loving the outfits and waiting to see what they had on."

"My mother has always been invested in making women feel beautiful," Beyoncé told the New York Times in 2017, "whether it was through someone sitting in her hair chair or making a prom dress for one of the girls at church. And her art collection always told the stories of women wanting to do the same."

Today, Tina's collection includes works from painter Henry Ossawa Tanner and sculptor Elizabeth Catlett, plus contemporary artists like Robert Pruitt and Toyin Ojih Odutola. She's a voracious reader of art books, especially on the lives of African American artists. "I think it was important to my mother to surround us with positive, powerful, strong images of African and African-American art so that we could reflect and see ourselves in them," Beyoncé told the Times. Tina is continuing that mission with WACO Theater Center in Los Angeles, which she cofounded in 2017 to mentor kids and adolescents through immersive art programming.

Both Beyoncé and Solange credit their mom's longtime passion for art, especially by Black artists, for the visual artistry and depth of meaning that they have been leaning into in recent years. In 2016, Beyoncé released her powerful visual album Lemonade. The alternatingly dreamy, fiery, mournful, and joyful film accompanying the album features contemporary Black artists, designers, poets, and writers. Beyoncé's subsequent project, Black Is King, a visual album accompanying her soundtrack for Disney's 2019 CGI reenvisioning of The Lion King, was another astounding celebration of African art and Black beauty. Beyoncé's mom and sister make appearances in Black Is King, as does her eldest daughter. Nine-year-old Blue Ivy even took home a 2021 Grammy alongside her mom's—a win that made Beyoncé the most awarded and nominated woman in Grammy history.

Meanwhile, Solange's artful 2016 A Seat at the Table brought in the voice of Miss Tina herself in a powerful, confidently spoken interlude: "I've always been proud to be Black. Never wanted to be

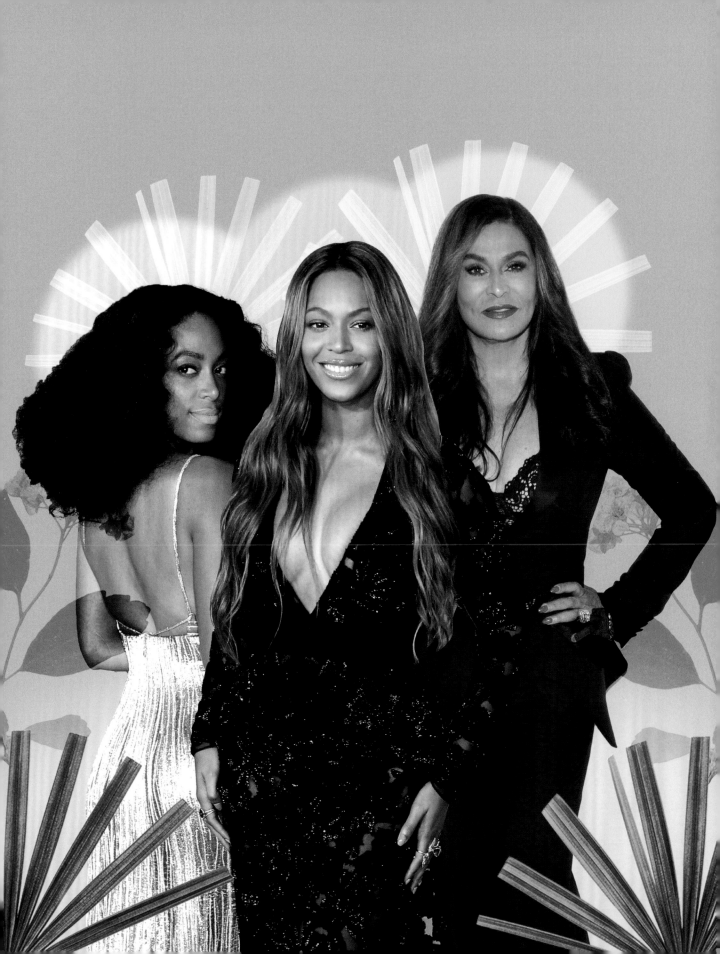

nothing else." And the white, ethereal, gold-fringed dress Solange wears in the video for "Cranes in the Sky"? Designed, of course, by her mom.

Both *Lemonade* and *Seat* were highly lauded and earned each artist a number one hit on the Billboard 200 chart the year they were released—making history as the first siblings to do so. "If my sister and my [work] feels like an 'awakening' to some," Solange said in 2017, "I am constantly saying that we both grew up in a home with two words: Tina Knowles."

STRONG WOMEN, WILDLIFE WARRIORS

Terri Irwin & Bindi Irwin

"Bindi!" Steve Irwin exclaimed to his seconds-old newborn in 1998. "Bindi, for my favorite crocodile, of course," he later explained. And the baby's middle name, Sue, honors the Australian TV and wildlife conservation icon's favorite pup, he added. Thus Bindi Sue Irwin came into the world as cameras rolled for her parents' show, *The Crocodile Hunter*.

Steve and wife Terri Irwin wasted no time folding Bindi into the wild world they loved, brimming with the same enthusiasm and passion for their work with wildlife as they did for their newly expanded family. Terri later revealed in *Steve's Story* (2010), a documentary on her late husband's legacy, that Bindi went on her first shoot in the wild at just six days old. She was six weeks when the family of three headed to Mexico in what would be Bindi's first overseas trip. There are clips of the still-wrinkly newborn on her dad's lap in a helicopter, rosy and napping while nestled beside him in a tent, and taking clunky toddler steps across Queensland's arid terrain while she grips her dad's fingers. Mom Terri is usually in frame, but it was clear that Steve was completely smitten by his daughter.

Stephen Robert Irwin (1962–2006), better known as Steve Irwin, The Crocodile Hunter, remains an icon of wildlife TV and a kind of Australian folk hero. His childlike wonder of the most dangerous creatures on the planet showed viewers that even the so-called villains of the animal kingdom were beautiful and that we

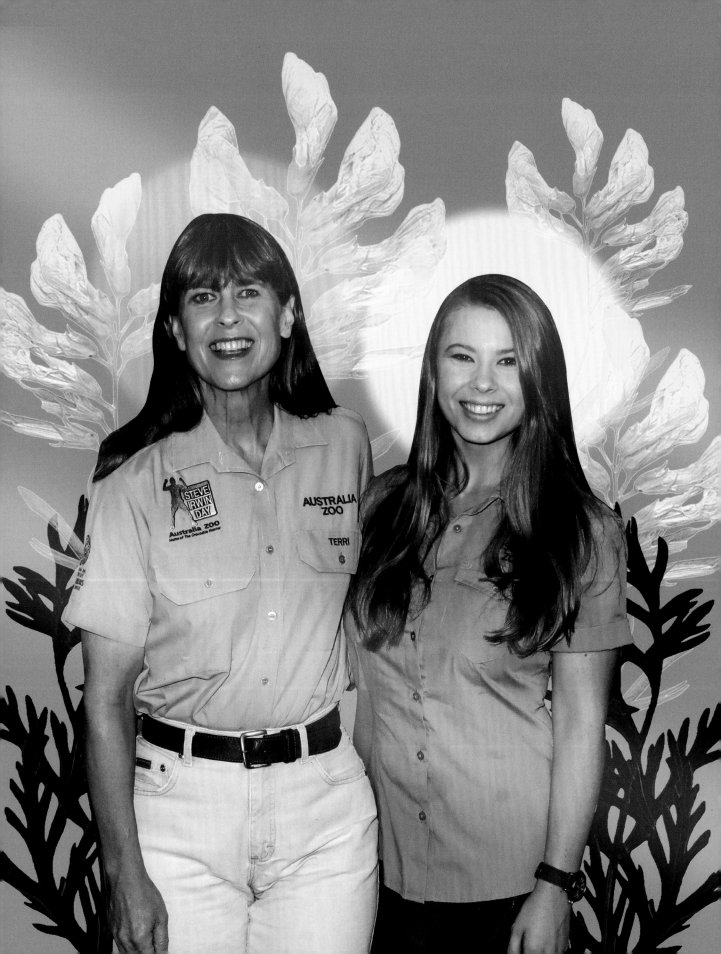

should respect and be in awe of their power. Fear of what they could do to him never discouraged that resolve—he'd unabashedly hold his hand up to the camera to admit he was "shakin' like a leaf!" during an encounter with a deadly poisonous snake or an especially ornery crocodile. His fans worldwide and his family were devasted when Steve died tragically in 2006, when a stingray's spine pierced his chest. It was the kind of tragic split-second accident that was always a possibility in his line of work.

Steve left behind a legacy, loving fans, and a close family—he and Terri had another child, Robert, in 2003. After his death, the Irwins never stopped the work that meant so much to their loved one. Terri continued to raise Bindi and Robert more or less in the Australia Zoo, the place founded by Steve's dad, herpetologist Bob Irwin. That's where she first met Steve in 1991. Of course, they continued sharing their work and family life with the world through TV series and specials.

Oregon-born, but a naturalized Australian citizen, Terri Irwin (neé Raines) once told *Eugene Magazine* that her upbringing in Eugene was "free-range." She spent summers biking and hiking in nature, catching glimpses of rattlesnakes or enjoying the snow at higher elevations. She credits her dad for her lifelong passion for wildlife conservation. He would often bring home injured wildlife to rehabilitate, teaching Terri that "taking the time to help another living being was essential." In 1986, years before joining Steve at the Australia Zoo, Terri had even founded Cougar Country, a wildlife veterinary hospital and rehabilitation facility in Eugene specializing in predator animals like cougars, bobcats, raccoons, and foxes.

Bindi might have been her daddy's girl, but she often says that her mom is her closest friend and model for living. "Mama," she wrote on social media one Mother's Day, "you will always be my Sarah Connor. Fiercely loyal, genuinely kind, and a total badass! You were born with a purpose to change the world. You're my best friend and every day you show me what it means to be a woman warrior"—a nod to Wildlife Warriors, the nonprofit Terri and Steve founded in 2002 to protect the world's wildlife and their habitats. Bindi told The Bump in 2021 that her dad coined the term "Wildlife Warrior" for those who "stand up and speak for those who cannot speak for themselves."

In partnership with the Australia Zoo, the nonprofit had by 2020 protected nearly half a million acres of property in Australia for conservation, Bindi explained, and had provided care for over ninety-four thousand wildlife patients, "with the goal of giving each animal a second chance at life and releasing them back to the wild." Together, Wildlife Warriors and the Australia Zoo fund efforts to conserve habitats for endangered species around the world like cheetahs and Sumatran rhinos, and they contribute to studies toward better understanding how we can protect our imperiled earth.

Bindi has grown up both in nature and on camera, honing her own brand of unwavering charisma and clear passion for the work she was literally born into. It was only fitting that she also found a partner just as aligned with her family's mission. "My dad used to say that I couldn't marry

anyone unless he could swim across the croc pond first," Bindi wrote on social media in a 2020 post dedicated to her husband, Chandler Powell. "They say there's a moment when you know you've fallen in love with someone; for me it was watching you happily jump in the water with a 15-foot crocodile and then tell me how much you enjoyed it. You are my soulmate."

The couple met at the Australia Zoo—just like Bindi's parents—where Chandler was volunteering. In fact, Terri told *The List*, her daughter's relationship reminded her of her own relationship with Bindi's dad—like a "comfortable, familiar pair of shoes. You can always count on them [to] hold up, they'll walk you through life. . . . They're dependable," she said. In 2019, twenty-year-old Bindi said yes when Chandler proposed. Plans for a big wedding changed as COVID-19 spread across the globe, but the couple looked perfectly happy with their intimate, family-only ceremony. Bindi even found a sunflower-lace gown that resembled the heirloom dress that Terri wore at her wedding in 1992.

More happiness was not far behind: Bindi and Chandler announced that they were expecting a baby girl of their own. Grace Warrior Irwin Powell arrived on March 25, 2021. She will no doubt grow up to bear the same legacy that the family has every intention of passing on. "We have filmed across the globe hoping to educate and inspire everyone to believe in their strength to change the world," Bindi wrote on social media. "We have dedicated our lives to standing up for the planet. It's up to all of us to make a difference for the generations to come. The future is in our hands."

AND THEY'LL BE STRONG ENOUGH

Oracene Price, Venus Williams & Serena Williams

Oracene Price's youngest child, Serena Jameka Williams, wrote an open letter to her mother in 2017, just after her own daughter, Alexis Olympia Ohanian Jr., was born. "You are one of the strongest women I know," she wrote. "I am proud we were able to show [that women] don't all look the same. We are curvy, strong, muscular, tall, small, just to name a few, and all the same: we are women and proud!"

Among the twenty-three-time Grand-Slam champion's four siblings is a fellow tennis icon, Olympic gold medalist and seven-time Grand-Slam winner Venus Ebony Williams. Together, Venus and Serena are the Williams Sisters, holders of fourteen Grand-Slam doubles wins and household

names in the world of tennis since their debut on the professional court in the 1990s as teens. The pure power, talent, and athleticism of each sister quickly redrew assumptions about female tennis players—and they forever changed professional women's tennis. "Venus and Serena raised the bar for everyone," Belgian champ Kim Clijsters told the *New York Times* in 2010. "We all had to go back to the gym. Younger players saw that, and now they're hitting harder and harder."

It was Oracene who introduced her girls to the game, even before they were born—Oracene learned to play while she was pregnant with Venus; she got the girls started when they were small. Their dad, Richard Williams, was their primary

coach. Oracene said once, "It's almost like they were raised on the court." She recalled that, even as kids, her daughters' work ethic and passion for the game were evident. "They had goals in mind," she told *Today* in 2019. "I saw them working so hard, and they never ever complained. Never said, 'I don't want to go.'" She realized she didn't need to tell them what they should have done differently after a lost match or frustrating practice. Instead, she said, you instill confidence and stand back: "I taught my kids to grow up and be self-sufficient and not to come back here, to me. They'll be able to take care of themselves, and they'll be strong enough."

Elder sister Venus was the first to make a big mark and be clear about who she was. After advancing to the final of the 1997 U.S. Open, Venus said, "I'm tall. I'm black. Everything's different about me. Just face the facts." Still, Venus is the quieter of the two, but Serena says her sister "wants to leave the sport in a better place than when she entered it." Venus fought for equal prize money and equitable treatment of women in tennis. Venus noted parallels between her activism and the effort to address systemic racism in the wake of the Black Lives Matter movement in 2020, writing: "[Just] as sexism is not only a 'women's issue,' racism is not only a 'black issue.' . . . When we fought for and won equal prize money, everyone pitched in, men and women, all colors, all races. And we won."

Charismatic and outgoing, Serena often draws backlash for her outspokenness. In 2018, an Australian newspaper ran a vicious and blatantly racist caricature of Serena. It was meant to portray a moment when the player heatedly called out a referee for a call she disagreed with—hypocritically critiquing and insulting her for the kind of anger that has made legends of white male players.

The sisters have long been subject to sexist and racist criticisms of their bodies and the way they play. The vitriol has never relented, even in the wake of endless wins over their more than twenty-five-year professional careers and hundred-plus combined titles. "Mom, I'm not sure how you did not go off on every single reporter, person, announcer, and quite frankly, hater, who was too ignorant to understand the power of a Black woman," Serena continues in her letter to Oracene. It seems her mom had an ability to block out the hate flung at her girls for decades.

As a Black woman married to a white man, with a biracial daughter, Serena has faced a new slew of insults in her personal life. She wrote that she hopes to draw on her mother's example and model for her daughter the kind of strength and power that Oracene showed her and her sister. "I was looking at my daughter and she has my arms and legs! My exact same strong, muscular, powerful, sensational arms and body. I don't know how I would react if she has to go through what I've gone through since I was a 15 year old and even to this day," Serena continues in her letter to her mother. "I only wish I could take your lead. I am trying, though, and God is not done with me yet. I have a LONG way to go, but thank you."

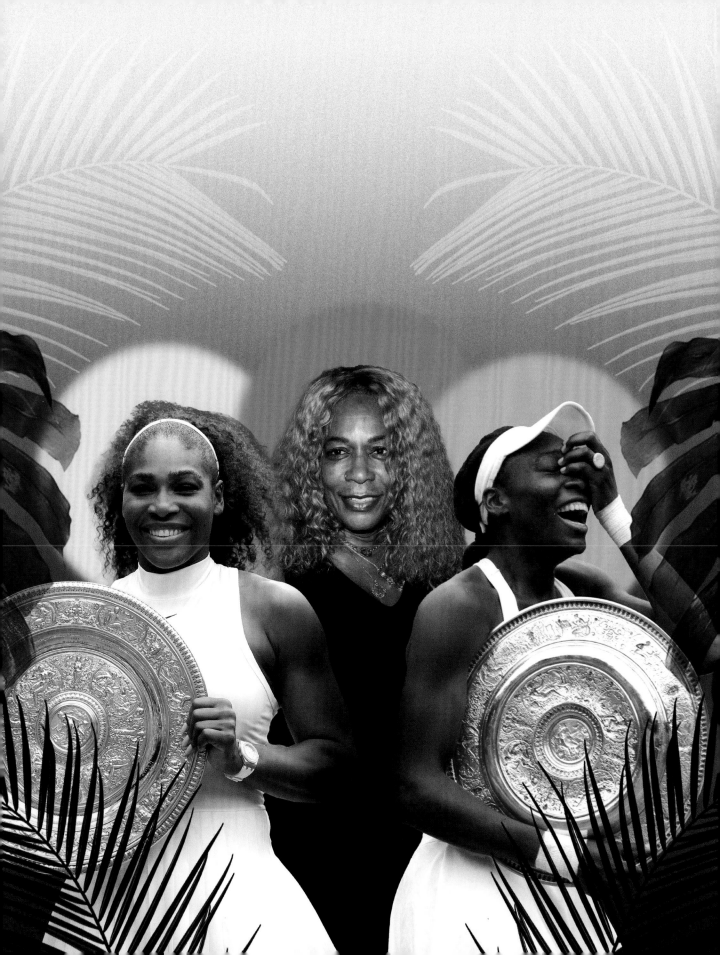

Chapter 4

To Thine Own Self

Reconciling your shadows and finding the light of your own way

Linda McCartney &
Stella McCartney

Jane Birkin &
Charlotte Gainsbourg

Nina Simone &
Lisa Simone Kelly

Judy Garland &
Liza Minnelli

*A*ny family can have a broad and complicated shadow cast by a beloved member. We are proud of them, but we also inevitably measure our lives against theirs. From childhood, we might be unfairly compared to this larger-than-life figure, with every photo, decision, and step of ours compared to theirs. Do we look like them a little or not at all? Do we have the same talents, the same charm? The same goals and dreams? The same drive?

For some women, the larger-than-life figure is a celebrated patriarch: Photographer Linda McCartney was often seen merely as wife to one of the Beatles, Paul McCartney, but fashion designer Stella McCartney says it was her mother's quiet dedication to her own work that encouraged her to pursue exactly what she wanted. After the loss of divisive French singer and actor Serge Gainsbourg and daughter/half-sister Kate Barry, Jane Birkin and Charlotte Gainsbourg have both learned what it means to be comfortable in your own skin.

For others, like Nina Simone's daughter Lisa Simone Kelly and Judy Garland's daughter Liza Minnelli, their talented mothers are cemented in the annals of entertainment as patron saints of music, the stage, and the silver screen.

The experiences of all these women reckon with what it means to share an ultrafamous mother, or a godlike husband or father, with the world. In this chapter, they show us how they've found— and defined—themselves.

LESSONS FROM THE PAST, FOR A GREENER FUTURE

Linda McCartney & Stella McCartney

The idea of following a dynasty, fashion designer Stella McCartney told the *Guardian* in 2019, was never thrust upon the children of musician and photographer Linda McCartney and über-famous Beatles member Paul McCartney. Growing up, Stella and her three siblings, including her sister Mary McCartney (also a photographer), never felt any pressure to embrace the music world, but to be just who they were and to pursue what made them happiest. The McCartneys' archive of more than two hundred thousand of Linda's loving, tender, and funny family photos more than makes that case.

Linda McCartney played in her husband's post-Beatles band, Wings, but her family insists that her true legacy is as a photographer. "I was a bit shy and introverted but looking through the lens I [could] forget myself and could actually see life," Linda told the BBC in 1994. "Photography changed my life in that way." Linda shot now-iconic images of musicians like B. B. King, Mick Jagger, and Janis Joplin; in 1968, her photo of Eric Clapton made her the first female photographer with a *Rolling Stone* cover. "Sometimes I would think, 'Oh, my God, these people are going to get annoyed; she's sticking a camera in their face,'" Paul told *Harper's Bazaar UK* in 2011. "But she just had this way about her where people just went, 'Okay,' and sort of smiled. The only person who ever said no was Bob Dylan. And even him, she shot later." But

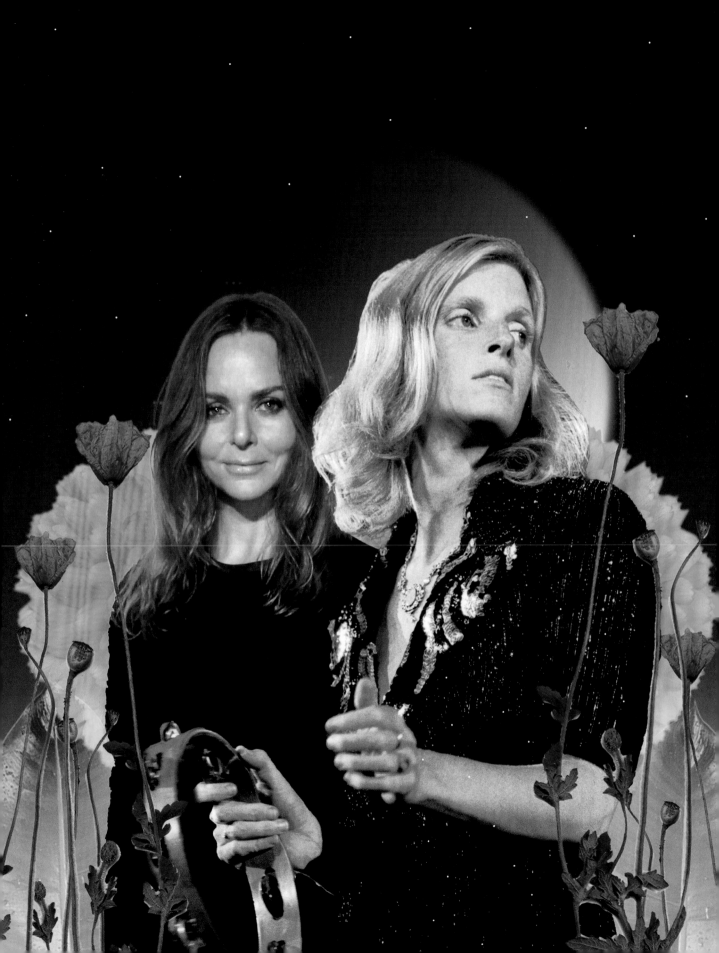

by far, Linda's favorite subjects were her husband and children.

Linda captured the young, beautiful family's life as it unfolded between their English country-side home and their Scottish farm in the 1970s and 1980s. Here are the girls riding horses; there's Paul cooing to two chicks in his cupped hands; and there's Linda turning the camera on herself to capture her blonde mullet, crop top, and cowboy boots for a day working on the farm.

It was meaningful for Linda's family to go through the photos for a 2011 book, *Linda McCartney: Life in Photographs*, and then again for 2019's *Linda McCartney: The Polaroid Diaries*. The family found that the process unearthed visual records of childhood memories and small moments that were reflected or amplified in their later lives. For Stella, her parents' cool ease with androgynous dressing and their love of nature made the greatest impression: two important details that led her to combine fashion and sustainability as a world-renowned designer.

"I was very aware, very young that I wanted to be a fashion designer," Stella told the *Financial Times* in 2019, commenting on a Polaroid of her dad boogying with Mary on his shoulders that Linda took in their Scottish farmhouse. There's a tartan visible around his waist, reminding Stella of the "magnificent" presence of tartan in their tiny Scottish town, which impressed the young fashion-lover.

She also recalled sitting in her parents' shared wardrobe as a four- or five-year-old and realizing that her parents shared almost everything in it. Half of what she thought were her mom's were things her dad wore all the time: "They would swap," she told the *Financial Times* in 2019. "I've since worn a flowery shirt [I thought was my mum's] and then we'd find a photo of my dad wearing it. It's so modern; this was years ago, but today it's a cutting-edge conversation to have. The influence is very heavy on how I work today."

Linda and her kids rode horses every day, Stella said, and her mom, a vegetarian, had a soft spot for all animals—they had a "menagerie" of rescues at the farm. That love and respect for nature also influences Stella today. She still loves horses and eats vegan, but she has taken it even further; in 2020, she recommitted her brand to sustainable practices, zero-waste production, and all-vegan materials.

She told the *New York Times* that she reflected on her company, which she had recently bought back from shareholders, during the COVID-19 lockdown. "Why do I do what I do?" she asked herself. "Why do people work at Stella McCartney? And why on earth would you be in fashion?" The result was a kind of manifesto in the form of an artist-illustrated A to Z list to answer her questions, including, *A* for "Accountable," with a painted letter by Rashid Johnson, and *T* for "Timeless," with a photograph by William Eggleston. Of course, *L* is for "Linda," paired with a photo of her mom from Stella's childhood. Much of Stella's list boils down to green practices, and taking collective action: "Returning to the world [post-COVID-19]," her manifesto reads, "we need to come together to speed up positive change. During that global moment of pause, we all saw that nature can heal. What's beautiful about the days we're

living in is that out of such trauma, disruption and reflection, this really is a time of hope."

As of October 2020, she told the *New York Times*, all Stella McCartney cotton and denim fabrics are 100 percent recycled, and the company is upcycling leftover materials from past lines and one-off prototypes that didn't see production. It's just a start, she said, and she has plans to do more—hopefully, leading the way for her luxury fashion peers, and carrying forward the example her mom set years ago preserved in so many treasured photographs.

NOTHING NEED
BE PERFECT

Jane Birkin & Charlotte Gainsbourg

"I realized recently that I love imperfection," Charlotte Lucy Gainsbourg told *Harper's Bazaar* in 2017. The Paris-born actress, musician, and face of Saint Laurent continued, "We're in a world that is digitally perfected. You have to look perfect, speak perfectly, be politically correct. Everything is polished." Charlotte is known to push back on magazines and media outlets retouching her photos to erase wrinkles and imperfections: "That imperfection is what makes me human, and [it's] what makes people interesting." In her forties, she sees no reason to pretend she's twenty.

Charlotte has been subject to public judgment and the pressures of fame from a young age. She's the daughter of a British-born mother,

model-actress Jane Birkin, an icon of effortless Parisian style and beauty, and a French singer father, the provocateur Serge Gainsbourg. Together, they were the ultimate it-couple of 1970s Paris.

Today, Charlotte is a successful actress (considered a muse to director Lars von Trier) and occasional recording artist since the 1980s. She is still seen by Parisians as Serge and Jane's daughter (the couple split when Charlotte was nine)—which can be paralyzing creatively, she has said. She told *Vogue* that feeling she had to live up to the expectation her parents set meant that often she "didn't dare try."

Charlotte's first experience with the spotlight came with some controversy. In 1984, Serge

released the song "Lemon Incest" (a play on "lemon zest") featuring his then-thirteen-year-old daughter. Charlotte says she was insulated from much of the backlash at the time, but has always seen the lyrics (about the kind of love they would never share as father and daughter) as "pure" of intention, with Serge's trademark twist meant to provoke his audience. The song topped French charts for ten weeks. "I was used to his excitement about provocation," she reflected to the *Guardian*. "This is what he was good at."

Paris eventually became stifling and overbearing for Charlotte. Her dad died suddenly there in 1991, when she was only nineteen. When her half-sister, the fashion photographer Kate Barry, tragically died by suicide in 2013, she decided she needed a change. Moving to New York with her longtime partner (Israeli-born actor and director Yvan Attal) and their three children in 2014 gave Charlotte the change she needed—emotionally, for sure, but also as a kind of creative-kickstart afforded by relative anonymity. "I could breathe again. I was liberated here. Not a lot of people recognize me [in New York]. . . . It was a new life."

She felt freer to explore her interest in photography and drawing and reawakened her music career. "[In New York] I feel I'm being myself with nobody noticing," she told the *Guardian* in 2019. "I feel very different, because I'm not looking at myself all the time. I don't think in France I could have released my album and written the lyrics myself." *Rest*, her deeply personal 2017 French and English album, explores motherhood, growing up, love, and grief; in a song titled "Kate," she sings,

"On d'vait vieillir ensemble" ("We should have grown old together").

Charlotte says working on *Rest* also led her to accept the "fragile" qualities of her voice and to embrace its imperfections. "I was never pleased with myself as an actor and also as a singer," she told *Vogue* after its release. "It took me a long time to understand this: that I preferred mistakes to a nice, perfect thing." She has taken to heart what her father taught her, she explained: Cultivate what is natural and unique to you; don't sand down your rough edges.

"I think women only start to really look like themselves after they turn 30," Jane Birkin told *Harper's Bazaar* in 2018. "That's when a girl first dares to be her own age, show her bare face, and not just dress for boyfriends or husbands." Now in her seventies, looking back at photos of herself from the 1960s, she says she can't relate to the "Barbie doll" she says she sees, but she wouldn't change it. As she told *Vice*, whatever your past looked like, "the rest of life is rather refreshing."

Born in London, Jane Mallory Birkin married the film composer John Barry when she was just seventeen. She was twenty when she became a mother to their daughter, Kate, though her marriage fell apart not long after. The twenty-two-year-old divorcée and single mom's life changed completely when the aspiring actress met famous French film star and singer Serge Gainsbourg. She'd had small roles in counterculture films like 1966's *Blow-Up* and *Kaleidoscope* before auditioning in France for the female lead opposite Serge in *Slogan* (1969). He first rattled, then charmed her, and they

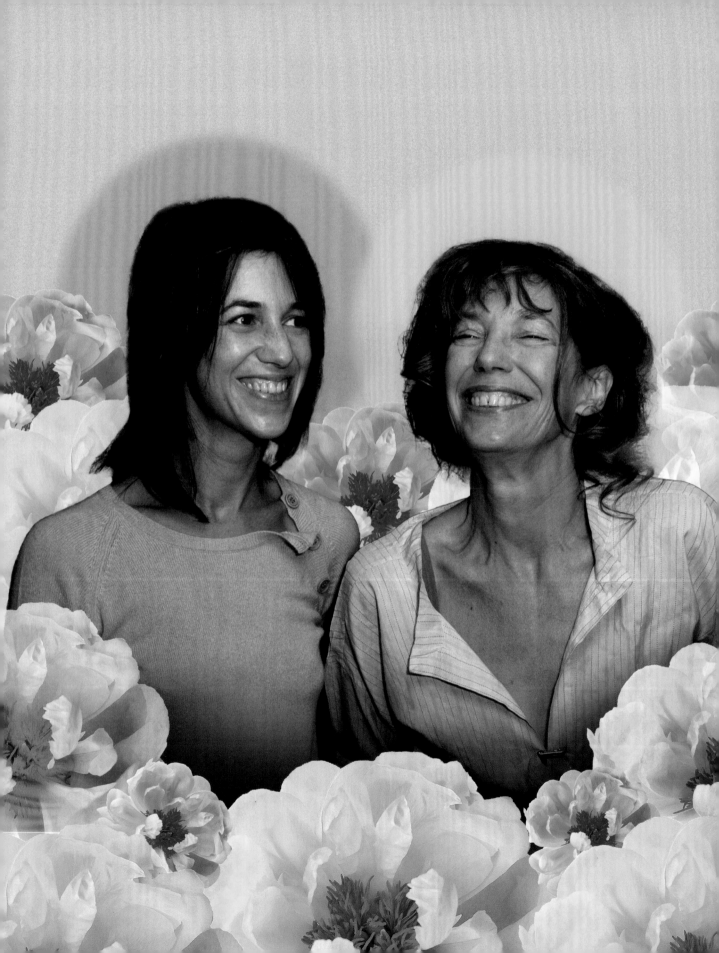

were soon inseparable. As a newly minted couple, Serge famously convinced Jane to join him on the breathy, moan-filled duet "Je t'aime . . . moi non plus" ("I love you . . . me neither")—which is, as *Vice* put it, "the sexiest song in history, banned by the Pope, and the first fully French single to top the charts in the UK."

They never married, but they were completely enamored of each other for a dozen years. By night, the young and beautiful couple stayed out until all hours and made headlines with their drunken antics and fiery relationship. By day, Serge wrote songs for Jane as she flitted around France and Europe for roles in good and "bad" films, she told the *Guardian*. Looking back, Jane says she approached it all with the laissez-faire of youth. Film roles were really an excuse to travel with her daughters—her mini in honey-haired Kate, and Serge's echo in brunette Charlotte. Likewise, Jane's nightclubbing and late-night partying with Serge were an excuse to be with him. "It was just all great fun," she told the *Cut*.

The "why not?" attitude extended to Jane's now-iconic fashion of those years. Even today, photos of her see-through crocheted minidresses and deep-plunge necklines, baby-doll eye makeup, perfectly tousled bangs, and ubiquitous Portuguese market basket still fill *Vogue*-style inspo lists and inspire *Harper's Bazaar* editorials. (And let's not forget her legacy in a namesake cult-favorite bag, the coveted Hermès Birkin.)

But near the end of her relationship with Serge, Jane wanted to move on from the "pinup girl" image. "I wasn't going to swing my hair around like Serge wanted me to or lick my lips [during performances]. . . . I didn't want to do that any-more." Before one show, Serge peppered her with questions and suggestions—"What're you going to wear? What sort of a dress?" she says he asked. "But you'll do your hair with curls in it." In a taxi heading to the show, she used manicure scissors to cut off her long hair. She wore a boy's shirt and trousers with a thin red belt and tennis shoes. "I felt great," she told the *Guardian*. "I think it changed my life after that and proved that I could do very much what I wanted to do."

Serge's struggles with depression and heavy drinking ended their relationship in 1980, but they stayed very close. "You could talk back to him for once," Jane explained to the *Guardian*. "You were not just his creation anymore." She was devastated by Serge's death in 1991, and in her grief ended her ten-year marriage to Jacques Doillon (with whom she has a daughter, Lou Doillon). Charlotte too was so heartbroken by the loss of her father that she didn't make music for over a decade after he died. Both women admit they'd put Serge on a pedestal, but neither think it is unwarranted. "He was a great man. I was just pretty," Jane has famously said of Serge and herself.

Kate's death dealt Jane another blow. She told *Bazaar* that she became a recluse for some years, but like Charlotte, she eventually channeled her grief into music: "Music helped me escape," she said of her decision to start performing onstage again in 2018. "I didn't have to think so much. And suddenly I knew what to do at night."

Just about all Jane wears now is sneakers, loose trousers, oversize cashmere, and maybe a classic

Saint Laurent smoking suit for formal occasions. Daughter Charlotte also opts for the ease of a white tee (albeit, Saint Laurent) and jeans under a blazer or cool leather or denim jacket. Sometimes, you can see the close pair onstage together in their effortlessly chic French ensembles, performing Serge's songs in tribute. The French idols are finding their own ways forward, while holding close their memories of a talented daughter and adored sister and the man they regard as bombastic, brilliant, and beloved.

FORGIVENESS COMES FIRST

Nina Simone & Lisa Simone Kelly

Lisa Simone Kelly is the only child of Eunice Kathleen Waymon—better known to the world as Nina Simone, the R & B, jazz, and blues singer with a voice that could range from "gravel" to "coffee-and-cream," as she once told an interviewer. She had a depth of voice that touched the soul; she was a true original.

"My mother was one of the greatest entertainers of all time, but that came with a price," Lisa tells viewers at the start of *What Happened, Miss Simone?* Lisa was the executive producer for the 2015 documentary about her mother's legacy. "People thought that when she went onstage, that that was when she *became* Nina Simone. My mother was Nina Simone 24-7," she explained. "That was [the problem]."

Even as a teen, Nina's talent and drive were always evident. Eunice Waymon was a classically trained pianist, practicing eight hours every day. She moved to New York in 1950 to attend Juilliard for a little over a year but was later rejected by the prestigious Curtis Institute. She realized at the time, with a shock, that it was because she was Black. But she stayed on in New York, playing piano and singing at nightclubs and bars to support her family back home. Worried that her mother would disapprove if she found out, Eunice adopted a stage name. She chose Nina (Spanish for "little girl"), her boyfriend's pet name for her, and Simone (for French actress Simone Signoret). "[Performing] was never a choice," Nina once told

an interviewer about her early career; it paid the bills, and the only thing she'd ever done was play.

Lisa Celeste Stroud was born in 1962, just a year after Nina met and married Andrew Stroud, her husband and manager for many years. "I am proud to carry on my mother's legacy, and I stand upon her shoulders," Lisa told NPR in 2015, but "I had to find my own path. And in finding my path, I had to learn how to forgive. And in order to forgive, I had to be aware there was something that needed to be forgiven."

As a young girl, Lisa knew only that her mother traveled a lot. Looking back at those early years, she realized how hard Nina worked to achieve a balance between ensuring that her daughter was cared for and maintaining the momentum of her professional career. "My mother sacrificed on so many levels, beginning with her heart," Lisa reflected to NPR. But the pressure from the industry, her abusive husband-manager, undiagnosed manic depression and bipolarism, and the constant push to work, work, work wore on her. "The kind of people that were in her life— my father, for example—that were supposed to protect her [were] not there." Her dad could be a bully, Lisa says in the documentary, and viciously abusive. But for years, Nina couldn't leave; her personal life and her singing career were under Andy Stroud's control.

"I equate my mother's career into two halves," Lisa said in 2015. "You have where she was singing love songs and she was just really relaxed, or appeared to be that way." This period is the first half of the 1960s; it encompasses her first hit, "I Loves You, Porgy," and initial fame; her life with Andy; and Lisa's early childhood. The shift came in 1965, when Nina performed "Mississippi, Goddamn" during the historic Selma, Alabama, civil rights march that year. Lisa explains that her mom's voice physically broke during that performance—she actually lost an octave that she never got back. But it also marked the start of the second period of Nina's career, "the period where she got mad, which she never came back from as far as I'm concerned. And even when you see the way she's singing the protest songs, she's much more forceful in her delivery . . . you can see the veins in her neck."

As the civil rights era in the United States unfolded, Nina once told an interviewer, "I could let myself be heard about what I'd been feeling all the time." As a girl, she was taught to be silent, to not complain about her experiences with racism. A dam broke inside her after Selma, and she poured everything unsaid into her music: anger in "Mississippi, Goddamn"; grief in "Strange Fruit"; and radical joy in "Young, Gifted, and Black." All were anthems of the movement, affirmation and catharsis, for what it meant to be Black in America.

Soon, she was playing only political songs at performances; her bookings waned, and her commercial career suffered. Although she was already suffering from the pressures of her career, she sacrificed her own self-care for what she saw as an essential cause. She alternated between periods of depression and erratic, even violent, outbursts. Eventually, she left the United States for good and moved with her daughter to Liberia. During the

years there, Lisa says, her protector became her abuser—Nina's undiagnosed mental illness manifested in verbal and physical violence. Lisa moved back to New York at fourteen to live with her dad.

Lisa spent years looking for her place in the world. She joined the Air Force and served for a decade before embarking on her award-winning career on Broadway—including roles in *Aida*, *Rent*, *The Lion King*, and *Les Misérables*. She is married to Robert Kelly, with whom she shares a daughter. She also has a career as a solo artist, for which she adopted the stage name of Lisa Simone Kelly.

Meanwhile, her mom struggled to find stability while living in Europe, alone and impoverished, for many years. With the help of friends, she eventually found medication that worked to stabilize her mental state, at the gradual cost of her fine motor skills. Still, she performed late into her life, for as long as she could. Nina Simone died of complications related to breast cancer in France in 2003 at the age of seventy.

Producing *What Happened, Miss Simone?* gave Lisa the opportunity to look, unflinchingly, at her mom's life and career from every angle. "I remember when I first saw the final edit of the film I didn't know what to expect," she told NPR. "I was watching it with my daughter and it was wonderful. . . . [The filmmaker] took a complex story and wove in and out of so many different experiences with such deftness and compassion and fearlessness. I thought, I can stand down."

MAKE YOUR OWN MARK

Judy Garland & Liza Minnelli

Growing up in the glow of a talented mother is something that Liza Minnelli knows all about.

Her mother was the beloved Judy Garland, the diminutive powerhouse singer who played Dorothy Gale in *The Wizard of Oz* in 1939, forever charming moviegoers and audiences. *A Star Is Born* might just as well have been written about her. Plucked from her Garland Sisters vaudeville act as a teen, she experienced a meteoric rise as the charming girl next door with the larger-than-life voice and was beloved around the world.

Liza May Minnelli was born in 1946 to Judy and her then-husband, director Vincente Minnelli. With such high-profile Hollywood parents, Liza was born famous—"I was born and they took a picture," as she put it in a 2020 interview with *Variety*. From the time she could barely walk, she says, she was performing, taking a little bow on the set of her father's movie as a toddler in 1947, and looking like a picture-perfect doll with her mother during breaks in the filming of *Summer Stock* in 1950. She was raised on movie sets and on the stages where her mother sang, but dancing was always her true passion. As a girl, she loved dancing for her father—and by her telling, it was Vincente whom Liza convinced to send her to school for dance.

When she moved to New York in 1961, she was determined to make her own mark: "I was absolutely concentrated on not doing what my mom did," she told *Variety*. "The hardest part was getting to be

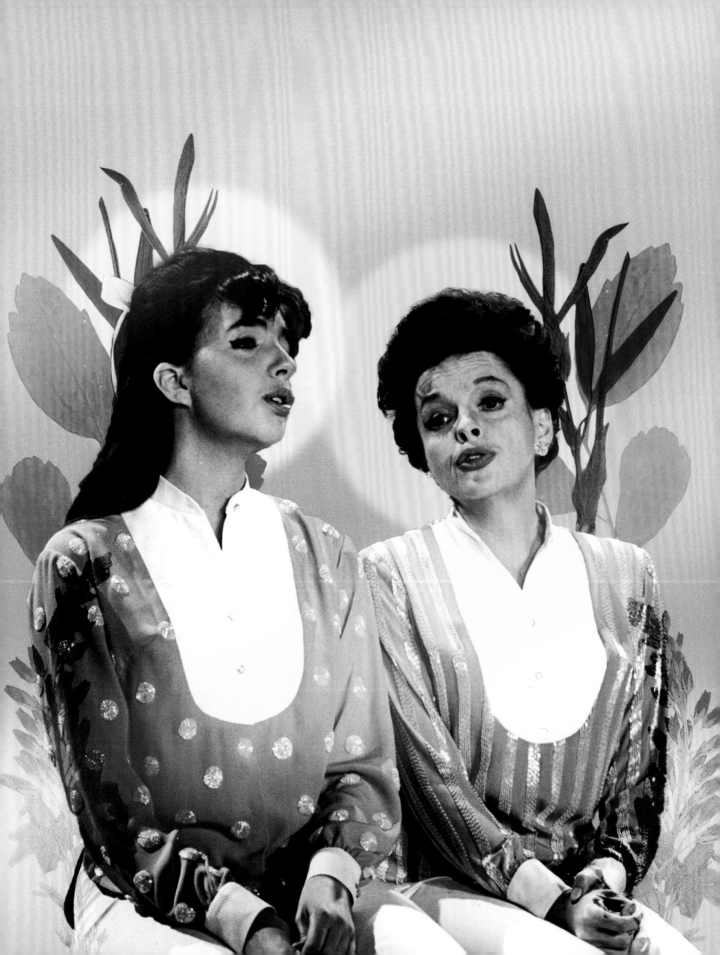

known as myself as opposed to somebody's daughter." As she pursued dancing and stage acting, she took on mentors outside her immediate family, singing with Tony Bennett and learning her best moves from French Armenian singer Charles Aznavour.

Liza's stage debut in the 1963 off-Broadway revival of *Best Foot Forward* was critically acclaimed, and she went on to win theatrical awards including Tonys for her stage work. By the 1970s, she was a style icon in her own right. She became a fixture at Manhattan's Studio 54 club, with her jet pixie cut, red lips, and glittery ensembles, and even inspired chic designer Halston. But it was when she took her triple-threat singing, dancing, and acting to the screen that her career really soared: Her Louise Brooks–inspired Sally Bowles in 1972's *Cabaret* is arguably her best-known performance.

Liza recalls her mother telling her not to get upset when reviewers drew the inevitable comparisons, but Judy was always the one who chafed. "She said, 'How dare they? You're your own woman. Dammit! Can't they see?'" Liza says. "She was wonderful and so overprotective. She tried saving [her family] from any of the stuff that other people said."

Judy passed away of an accidental overdose in 1969 at just forty-seven years old. She had long fought the grip of addiction to amphetamines and barbiturates, referred to as "pep pills," thrust upon her by those managing her career to keep her energy up and her weight down, and to help her sleep. Her condition was exacerbated over the years by alcoholism, anorexia, and prolonged emotional and mental distress. Liza has had her share of struggles with addiction and alcoholism, poor health, and bouts of debilitating depression. Often, the worst of it unfolded in the tabloids, providing fodder for the detached and unsympathetic public that watched her mother's tragic unraveling.

Today, Liza is a rare EGOT—a recipient of an Emmy award, a Grammy, an Oscar, and a Tony—and inarguably a star in her own right. A new generation fell in love with her comedic role as cougar Lucille Two on the cult favorite TV show *Arrested Development*, and in interviews today, she comes across as funny, unpretentious, and comfortable in her own skin. But when she does have a low moment or feels critical of herself, she says, she often summons the voice of Judy Garland: "She'll say, 'Ignore it. . . . It's one opinion. Who cares? Just keep going.'"

Chapter 5

Finding Connection

Achieving common ground as family and empathy as humans

Jada Pinkett Smith
& Willow Smith
(with Adrienne
Banfield-Norris)

Jane Fonda &
Mary Lawanna
Williams

Sridevi Kapoor &
Janhvi Kapoor

Jeon Young-nam &
Sandra Oh

We don't always understand our mothers or our daughters. We often feel we are misunderstood by them too. Most of us have felt the empty air where there could be deeper connection. We've felt the frustration of wanting to communicate our best intentions and not succeeding. We've had the desire to tell them about our real selves and life experiences but instead said nothing.

Recognizing this gulf between us can be an opportunity, under the right circumstances, to close the gap by practicing empathy with our loved ones. But being open, listening, and setting aside ego is an active process that takes real work—something the women in this chapter know about.

Jada Pinkett Smith was surprised and stung when her daughter, Willow, confessed that she didn't really know her mom as a person. Jada invited Willow and her own mom to start a talk show together that would put their intimate conversations in front of the world—and the results were more than the women imagined.

When Jane Fonda met fourteen-year-old Mary Lawanna Williams at Jane's summer camp, they felt an instant connection—and soon Jane saw that the girl was in need of intervention or she'd be lost.

Some mothers hope that their daughters will not travel the same path and make the same choices that they did. Janhvi Kapoor followed her mother, Bollywood's late queen Sridevi Kapoor, into acting, against her mother's wishes.

Expectation is something that Sandra Oh struggled with while growing up with her Korean immigrant parents, including a biochemist mom, Jeon Young-nam, who initially didn't see what good her daughter could bring to the world through acting.

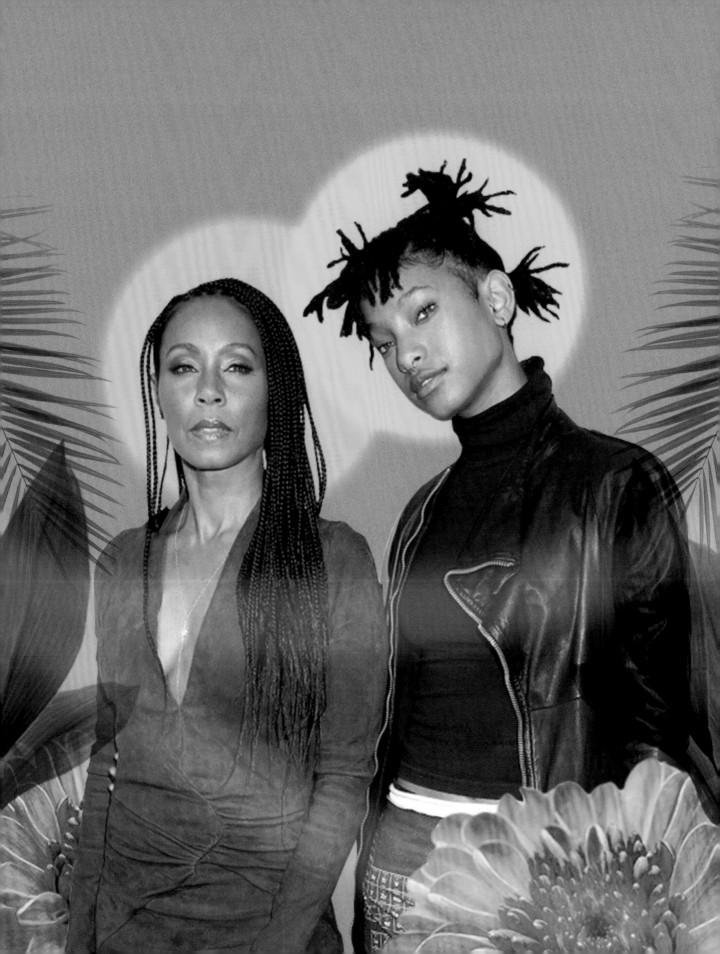

THE POWER OF VULNERABILITY

Jada Pinkett Smith & Willow Smith
(with Adrienne Banfield-Norris)

For Jada Pinkett Smith and her daughter, Willow, and her mom, Adrienne Banfield-Norris, a round, red table has become a symbol of honesty and emotional connection between the three generations.

Their web show, *Red Table Talk* on Facebook Watch, is built on conversations in the matrilineal circle on a wide range of topics, notably family, #MeToo, sex, marriage, vulnerability, and mental health. Occasionally, the women are joined by other family members (like Willow's father, Will Smith, and her brother Jaden Smith) or celebrities from the Smith family circle (like Gabrielle Union, Demi Moore, and Moore's daughters). Part late-night kitchen table truth-telling, part family therapy session, the show has given the women the chance to

air deep wounds and unsaid feelings, share regrets and mistakes, and celebrate what they love most in one another.

The very first episode, aired on Mother's Day in 2018, focused aptly on motherhood. Willow heard for the first time the struggles that her grandma—called Gammy on the show—went through as a teen mom raising Jada. Jada thanked her mom for coming with her to care for her young kids while filming *The Matrix*, explaining what it meant to her to have childcare support and be able to continue working.

Jada Koren Pinkett married superstar actor Will Smith in 1997. Together they have Willow (born in 2000) and her older brother Jaden (born

in 1998). Barely into adulthood, both Smith kids are already huge creative talents of Gen Z. On the show, Jada shares that she always worked hard to create a safe and stable environment for the two of them to thrive, and that meant concealing her insecurities and fears from her family and putting herself on hold.

In 2019, Jada told *Insider* that when Willow was nine, her daughter admitted to her that she didn't think she really knew her as a person, only as her mother. "And she was right, because there was so much history that I had—before I became a mother . . . that she knew nothing about," Jada said. "I think from that time on it was a journey towards being able to open myself to her and to myself in a different way." Through their conversations on *Red Table Talk*, especially, Jada says that she has learned more and more that being vulnerable in front of Willow is not weakness—it shows Willow that she can also share her lowest points with her mom.

In one episode, Willow shared that she'd once self-harmed: "I was plunged into this dark hole. I was listening to dark music, and I started cutting myself," she says, explaining that she was depressed after the release of her hit, "Whip My Hair," when she felt pressure from the record company to release a full album. She was only nine at the time. That revelation surprised Jada and Gammy—neither of them had any idea that Willow had been going through anything so dark at the time. They regretted that she thought she was so alone in those moments.

Changing the way you process your own emotional baggage and history so that your kids can have stronger tools and healthier coping mechanisms is not easy, Jada says, and it doesn't end. The important thing, she urges, is to keep listening: "Sometimes you have to hear things over and over again for them to land," she told *Insider*. "But deep listening, and sometimes just acknowledging and validating the experience of your loved one, is deeply healing."

FAMILY CAN BE FOUND

Jane Fonda & Mary Lawanna Williams

"She was bubbly, she had this laughter like wind chimes," Jane Fonda told Oprah Winfrey in 2011 about when she first met Mary Lawanna Williams. Mary, who went by her middle name as a child, and her siblings attended Laurel Springs Children's Camp that Jane founded in Santa Barbara, California. "But she came back two years later, and was a different person." Jane recalled seeing a kind of resignation and deep sadness in the bright girl she called Lulu.

When Mary was fourteen, she was raped by a theater director during what she'd thought was an acting audition. She confided in Jane when the journalist, actress, and activist pulled her aside. Jane also learned that Mary's home life was deteriorating and

that she had no real support system. As Mary wrote in her memoir, she was drowning.

The second-youngest of six children, Mary was born in East Oakland, California, in 1967. Mary describes her biological mother as an amazing cook, stylish dresser, and hardworking parent. She idolized her handsome dad. Both her parents were Black Panther Party members, and Mary remembers the communal care and structure of her childhood in the Panther community: after-school care and educational programs, hot breakfasts and lunches, lots of playmates and trustworthy adults. It contrasted sharply with the life she lived after her father (who was incarcerated during her early childhood) was released from prison and her

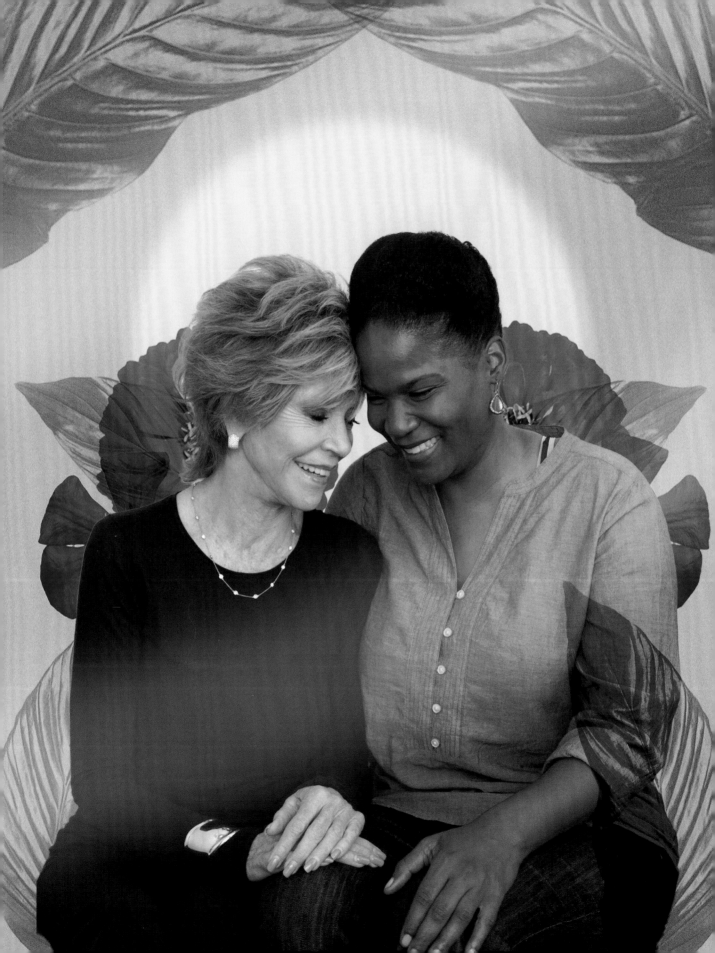

parents divorced. She saw less of her dad, and her Panther support system also dissolved by the time Mary was fourteen and struggling with the trauma of the assault.

Jane told Mary that she could move in with Jane and her family. She could live with them as long as she needed to.

Mary's mom gave her blessing, and although there wasn't a formal adoption, Mary moved into Jane's hacienda-style estate in Santa Monica in 1982. Mary became an older sister to Jane's biological children, Vanessa and Troy, and found a father figure in Jane's husband at the time, Tom Hayden. "[Jane] sat me down soon after I arrived," Mary wrote, "and said, 'I see you as my daughter now. If you want, you can call me Mom.'"

But suddenly living in Jane Fonda's very white and wealthy world could be disorienting, Mary shared in her memoir. "Even something as seemingly simple as dinnertime was fraught," she wrote. Her encounters with "white people food" were rife with anxiety—fresh cactus, baked Alaska, and artichokes stand out in her memory. There were times she felt resented by the Black community for living with this rich, white Hollywood family. But she says Jane tried to keep her connected to her heritage and the Black community. In 1989, Jane took her to Atlanta for the Martin Luther King Jr. Day services at Ebenezer Baptist Church. "Once she even called up Diahann Carroll to get a recommendation for a good hairstylist," Mary writes in her memoir.

"No matter where I end up, I'll always have my families," she reflected in *The Lost Daughter*. She has two mothers, one biological, the other found. Both showed her love that led Mary to the person she would become.

Mary has always been most impressed by Jane's passionate work as an activist and advocate for human rights. In the 1960s, Jane worked on behalf of Native American rights organizations and the Black Panthers, and she earned a divisive reputation in the 1970s for her vehement protests of the Vietnam War. Jane has continued her activism into her eighties. In 2019, she started "Fire Drill Fridays" (named for Greta Thunberg's statement that "our house in on fire") in Washington, DC, to protest the Trump administration's climate change denial and deliberate inaction. The protests frequently ended with Jane's arrest.

Today, Mary Williams is an avid hiker, environmentalist, author, and activist, like Jane. She started out as a fundraiser for organizations supporting refugee relief before learning about the war and violence in Sudan. Mary founded the Lost Boys Foundation in the early 2000s and turned her experiences with young refugees into her first book, a 2005 memoir called *Brothers in Hope: The Story of the Lost Boys of Sudan*. Having once been brought low, perhaps Mary connects deeply to what it can mean for an individual in need to receive help from someone in a position of privilege. "I had given up on myself," she reflected in *The Lost Daughter*. "[Jane] threw a lifeline and I grabbed it."

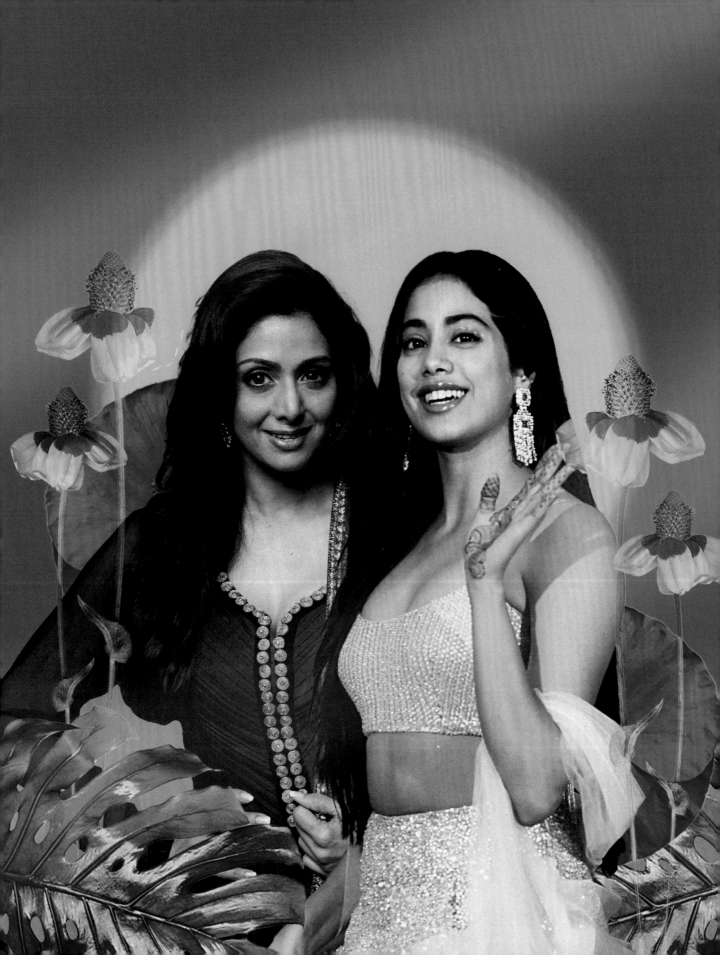

LOVE WHAT YOU DO,
AND MAKE AN IMPRESSION

Sridevi Kapoor & Janhvi Kapoor

South Asian actress Sridevi Kapoor was born Shree Amma Yanger Ayyapan in 1963—she was known simply as Sridevi to her adoring fans. The Indian actress was the first pan-Indian megastar, dominating the country's biggest industries, called Bollywood, Kollywood, and Tollywood (they make films in the Hindi, Tamil, and Telugu languages, respectively)—a difficult feat even for male actors in the notably patriarchal South Asian movie industry, according to Al Jazeera.

When Sridevi passed away in 2018, a victim of accidental drowning, the outpouring of grief across the Indian subcontinent, and from world-wide admirers, fans, political leaders, fellow actors, artists, and entertainers, showed the breadth of her influence.

Sridevi left behind two daughters with her husband, Bollywood producer Boney Kapoor. Her eldest, born in 1997, is Janhvi Kapoor. Janhvi grew up wanting to be just like her beautiful and talented mother. But Sridevi initially did not want her to follow in her footsteps: "She never wanted me to be an actress," Janhvi revealed to *Vogue India* in 2018, after her mom's death. "She thought I was naïve, that I wasn't thick-skinned enough. She wanted [her daughters] to live a more relaxed life." Her mother thought the disposition of Janhvi's sister, Khushi, better suited her to the business. She was protective of Janhvi, who admits to being the family's "baby" even though she isn't the young-est. Sridevi knew how difficult the high-pressure movie industry could be. "She loved what she did

but, you know, it was intense," Janhvi reflected. Her mom seemed to relent, she said with humor, after one argument ended with Janhvi in tears. Sridevi admitted that her daughter still looked pretty while crying—a good trait for an actress, according to the veteran performer.

Janhvi had started filming her debut, a romance for Bollywood called *Dhadak*, before her mom died. She got to show her mother an early clip of the movie, she told *Vogue*. "She was very technical about it," Janhvi said. "The first thing she told me was the things I needed to improve. Like, she felt my mascara was smudged and it really bothered her. The second half has to be different. She told me, 'You can't wear anything on your face.' That's all she told me but she was happy."

The movie was released five months later to middling reviews, but it didn't discourage Janhvi, who is happily living her "dream" as an actress. In 2020, Janhvi played the title role in *Gunjan Saxena: The Kargil Girl*, a biopic of one of the first two female combat aviators commissioned to fly into battle during the Kargil War. "Mum always told me, it's not about the kind of role or movie you do," Janhvi told *Vogue India*. "You need to make an impression—that's an actor's job. She never encouraged jealousy or frustration. We're capable of being happy for others."

She misses her mother. Janhvi wrote on Instagram, "There is a gnawing hollowness in my chest that I know I'll have to learn how to live with. Even with all this emptiness, I still feel your love. . . . I want to make you so proud."

FOLLOWING YOUR HEART
AND FINDING PURPOSE

Jeon Young-nam & Sandra Oh

When she first flipped through the script of *Killing Eve*, Sandra Oh wasn't sure what role the producers had in mind for her. She expected to be offered the part of a doctor or receptionist or other side character; that was the type of role she was typically asked to play and that she'd inevitably turn down. She had promised herself that she would only accept roles central to the main plotline of a story. Four years prior, she had ended her near-decade run on *Grey's Anatomy* in the role that made the Korean Canadian actress famous. Her performance as Dr. Cristina Yang, a dry-humored surgeon, earned her five Emmy nominations in a row and made her the first Asian to win a Golden Globe for best supporting actress.

Her agent explained that they wanted her for the *lead* in *Killing Eve*, even though the central character of MI5 agent Eve Polastri was written as a white woman in the books by Luke Jennings. Phoebe Waller-Bridge's version for BBC America made Sandra the first female Asian lead in a mainstream TV drama. Sandra spent her thirty-year career used to the fact that white actors are asked to play the leads, and nonwhite talent pick up supporting and fringe roles, and even then, in moderation: "Being the sole Asian person [on set] is a very familiar place for me," she told *Harper's Bazaar* in 2020.

Sandra Miju Oh was born in the small town of Nepean, a suburb of Ottawa, in Ontario, Canada, in 1971. Her parents emigrated from Korea in the 1960s and raised Sandra and her brother and sister in a middle-class community. Her father, Oh Jun-su

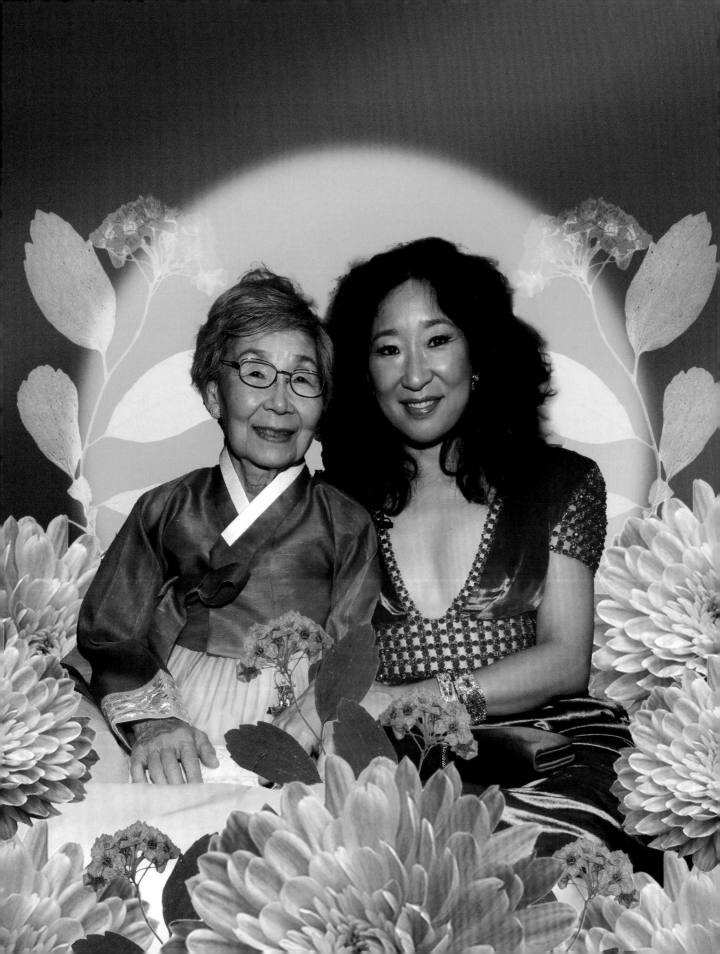

(John), was a businessman, and her mom, Jeon Young-nam, was a biochemist.

Sandra says that her parents were strict and expected a high level of academic performance from their children. "Western society is all about being super-supportive and believing in your children," she said, but having parents who expected more from you isn't necessarily negative: "Not being satisfied gives you drive; it's not bad."

After seeing a rendition of *Annie* as a child, she told the *Globe and Mail* in 2007, "I basically freaked out. Like, I had to do what they were doing." As kids, she and her sister would even stage plays for their parents, and in high school she joined an elite drama club, an improv team, and a comedy troupe. And this was in addition to being an A-average student, ballet dancer, flute player, and student-body president.

A pivotal moment came in 1990, when Sandra was accepted to the National Theater School of Canada and also offered a four-year scholarship to the journalism program at Carleton University in Ontario. Her parents tried to convince her to accept the scholarship and get a degree. Her mother saw acting as "low," which Sandra cited as a Korean cultural perspective.

"It was really tough," she told Ellen DeGeneres in 2007. "They'd go, 'What's the purpose of it? What is the social purpose of what you're doing?' Because they really, really instilled in all of us, my sister and my brother, that whatever you have to do has to be good for society." Her parents couldn't understand how acting contributed to the good of society. Today, Sandra says she is the only one of her siblings without a master's degree.

Her older sister is a lawyer in Vancouver, British Columbia, and her younger brother is a geneticist living in Boston. Her immigrant parents, Sandra later reflected, didn't want a competitive and insecure acting career for their daughter, especially with what they saw as the added complexity of being nonwhite in a looks-obsessed industry. They relented, but Sandra had to find a way to pay for school herself. "She had so much passion," her mom said in 2007. "She said to us, 'If I don't take this, I'll never forgive myself.'"

Sandra was just nineteen when she was cast in her breakout role as the lead in the CBC biopic *The Diary of Evelyn Lau*. The film portrays the Canadian poet's troubled years as a runaway teen, sex worker, and drug addict. It was a seven-hour bus ride from Sandra's school in Montreal to the audition in Toronto. In the casting room, she famously asked for a moment to center herself and proceeded to lay prostrate on the floor for over five minutes. Then she read her monologue and, of course, nailed it.

Before attending a screening of the movie in Toronto with her family, Sandra asked her sister to prepare their parents for her role. Her playing a heroin-addicted teenage sex worker, she worried, would not go over well with them. "But that was the first time my mother said to me, 'That must have been really hard,'" she said, remembering being both surprised and touched. "And maybe it was the first time they saw that there was a true sense of worth in what I was doing. That was very meaningful to me."

Twenty-six years later, she would get to share a similar moment in front of the world—

one retweeted and applauded especially by children of Asian immigrants across social media. In her speech at the Golden Globes in 2019, accepting her win for best actress in a drama series for *Killing Eve*—she's the first Asian actress to win the awards for both best actress and best supporting actress in that category—she ended by saying: "Mostly, there are two people here tonight that I am so grateful that they are here with me. I'd like to thank my mother, my father." Sandra then told them tearfully in Korean that she loves them, and she bowed. Her gray-haired parents were teary-eyed and smiling from the audience, and her dad returned the bow lovingly. Clearly, they couldn't have been more proud.

Chapter 6

Forging a New Path

Supporting each other through life changes and new directions

Katy Schafer &
Hunter Schafer

Debbie Reynolds,
Carrie Fisher &
Billie Lourd

Diana Jiménez Medina
& Salma Hayek Pinault

May May Miller
(Ci Zhang) &
Chanel Miller

*I*t's fitting to end this book the way it began: Our mothers often imagined we would always do as they do. *But just as some of us are lucky enough to feel supported in the same footholds that carried our mothers upward, it's probably more common that we will choose our own way.*

Trans model and actress Hunter Schafer's mom, Katy Schafer, had to learn to let go of who she thought her child was or risk losing her.

Late in her life, Debbie Reynolds found closeness with her daughter, Carrie Fisher, after Carrie had struggled with the worst of her addiction and mental illness—and Billie Lourd, the surviving progeny of two icons, is left to find her own path forward.

Opera singer Diana Jiménez Medina knew her "Salmita"—Salma Hayek Pinault—was destined for something great, even if her daughter's debilitating fear of performing live kept her from following her mom to the stage.

And artist Chanel Miller learned that the darkest moment of her life was not something she need bear alone—especially with a mom as resilient as May May Miller (Ci Zhang).

LETTING GO OF WHO YOU THOUGHT THEY'D BE

Katy Schafer & Hunter Schafer

You can't ignore Hunter Schafer. The willowy, platinum-haired actress made her acting debut as Jules in HBO's *Euphoria* alongside Zendaya's Emmy-winning role as Rue. Before that, Hunter was a runway model, scouted as she was planning to attend Central Saint Martins College for fashion design. She's walked for Vera Wang, Rick Owens, and Helmut Lang, among others.

But she was just seventeen when her name was in the national news, the youngest of several North Carolina plaintiffs in the American Civil Liberties Union's lawsuit to challenge the state's House Bill 2. The controversial "bathroom bill" forced individuals to use bathrooms that corresponded to the sex assigned to them at birth. HB2 meant that trans people would be forbidden from using the room that corresponds to their gender identity.

The teenager worked closely with ACLU lawyers, sharing her life experience as a trans person in her personal testimony for the case. Hunter was assigned male at birth and transitioned as a young teen. The battle against HB2, as she saw it, was by extension a fight against the discrimination of trans people in all spaces, public and private. "When I began to pass as a cis woman, I was able to start using the women's restroom without question—because I didn't 'look like a man,'" Hunter wrote for *i-D* about the case. "The more beyond the binary you are, the less safe you are, is the reality," she told *W* magazine in 2018. The

law, she continued in *i-D*, "signified to me that my peers and society cared more about how I appeared than how I openly identified." The bill was repealed in 2017 only to be replaced with a similar local law. Today, more laws have been put in place that threaten the rights and safety of trans people.

"I came out to my parents as gay in seventh grade—like a gay boy at [the] time," Hunter told WUNC in an interview with her parents in 2016. "But gender identity was still a very separate thing from [my sexual orientation]." But by her eighth-grade year, she says, emerging secondary male sex characteristics like facial hair terrified her. It was a feeling of "dread and wrongness."

"It was always there. We just didn't know what to call it," Katy Schafer said in 2016. Hunter is the eldest child of Katy and her husband, Pastor Mac Schafer, who both work for their church in Raleigh, North Carolina. Katy remembers that Hunter was drawn to all things traditionally feminine all her life. When Hunter was three, Katy asked their preschool teacher: "Is this 'normal' that our kid comes to school every day and puts on a pink dress, when all the other little boys have on plaid vests and fireman coats?" Hunter was expressing who she was—they just didn't always understand.

Hunter was twice rebuffed by her parents when she tried to come out as transgender. But the stress their child was experiencing became something they could no longer deny: "The anxiety level in Hunter was so apparent that I know that we could not continue [turning a blind eye] or not listening," Katy said. "I felt like we were reaching a crisis point, because we had kind of lost our kid. I think Hunter was just really struggling inside, and the anxiety was coming out. . . . It was kind of just this reality of we were going to have to let go of who we thought our kid was going to be." Hunter began her transition in high school, and the family of five had to navigate what that meant for Hunter's school life and with their church and community. At first, Katy had a hard time knowing how to refer to Hunter. Her daughter's friends set an example for her by adopting Hunter's pronouns with ease.

Hunter's *Euphoria* character, Jules, has a painful history with her unsupportive and absent mother, something that separates the character from the actress. But otherwise, Jules is actually based on Hunter's experiences as a trans teenager. She worked closely with the show's creator, Sam Levinson, to interweave her story into Jules's. As she told i-D in 2019, it was uncomfortable at first to make her personal story into entertainment for millions of viewers. "Part of surviving [that] experience was just, like, getting through shit. Letting it rest, and not addressing it. I think that's what I had been [doing] up to that point: just going and going, fighting to be on the other side of my transition." She hadn't looked back on her experiences, but the show allowed her to do that, even reliving moments through Jules: "As we worked through different scenes, I'd have to remember a new detail, to dig up an artifact from within myself, and hold onto that moment for the scene."

Between a supportive family and skyrocketing fame, Hunter is positioned for a successful and

groundbreaking career, while acknowledging that her platform is a privilege. She told i-D she doesn't see herself as an activist, but "I am trying to lift my trans siblings up, and my gender-nonconforming siblings and those of color, and trying to use this platform for them." On North Carolina public radio, she explained: "I do like people to know that I'm not a cis girl because that's not something that I am or feel like I am. I'm proud to be a trans person."

TELLING THE REAL STORY

Debbie Reynolds, Carrie Fisher & Billie Lourd

"I am my mother's best friend," Carrie Fisher said in *Bright Lights*, the HBO documentary about the dynamic, squabbling duo of Carrie and her mother, dancing and singing phenom Debbie Reynolds. The film follows the two women over about a year, with Carrie fussing over and teasing her mother as the octogenarian insists that each show she books is going to be her last. The film was released after both women passed away in December 2016.

The film also delves into the past, honoring Debbie's talent and love of the stage from an early age. She was only nineteen when she filmed *Singin' in the Rain* (1952) alongside Gene Kelly. She later starred in *The Tender Trap* (1955) with Frank Sinatra, and her rendition of "Tammy" from *Tammy and the Bachelor* (1957) hit number one on the Billboard music charts. These are just a few highlights from her impressive oeuvre. Debbie married Eddie Fisher in 1955—at the time, he was a superstar singer loved around the world. Together, they were one of Hollywood's golden couples, gracing the covers of magazines and gossip publications. The addition of Carrie in 1956 and her brother, Todd, two years later seemed to solidify the Fishers as the perfect family. In *Bright Lights*, Carrie recalls feeling from an early age that they were constantly getting dressed and preened for photo shoots in their gorgeous, if a little austere, Hollywood Hills mansion.

Scandal rocked the beautiful family when it was revealed that Eddie was having an affair with Debbie's good friend, the bombshell Elizabeth Taylor. When he left Debbie for Elizabeth, Carrie was only three years old. He would be an

inconsistent presence in her life from then on—a source of deep heartbreak that never healed. Her mom would marry and divorce twice more, but in many ways, Carrie was the love of her mom's life, always there to support her—and Carrie also needed the grounding presence that her mother became for her.

Debbie recalled in *Bright Lights* that she really saw a change in her daughter as a young teen. Periods of moodiness and lethargy followed by rebounding, super high-energy spells plagued Carrie from then on. For many years, there wasn't a word for what they would later learn was bipolar disorder. As a young woman, Carrie named her two moods: "Pam" for her low points and "Roy" for her energetic highs. Reckless curiosity drove her to experiment with drugs and alcohol early on, she recalled in *Bright Lights*, and she eventually used them to self-medicate for her underlying mental illness.

Still, fame came for Carrie with her role as Princess Leia Organa in *Star Wars* in 1977 and its sequels in 1980 and 1983. She would appear in other films and projects over the decades of her career, but all her life, she would always be Princess Leia to fans. She reprised her role in the three final *Star Wars* films, Episodes VII–IX, but passed away just after filming *The Last Jedi*. Her mom, heartbroken and already ailing, died the next day from a stroke.

Carrie and Debbie are survived by Billie Catherine Lourd, born to Carrie and then-husband Bryan Lourd in 1992. Like many kids of divorced parents, Billie grew up between two pretty different households—one of stability and quiet and one that could be fun but unpredictable: "[My dad] gets home at the same time every day, and we eat dinner together, we do homework together, we watch [TV] and then go to sleep. At Mom's it was like, 'Let's put Christmas lights in the palm trees at 2 A.M.'"

"The fact that I can make somebody laugh at this stuff—it can be very cathartic," Carrie would later say about why she chose to be open about her life. "If you claim something, you can own it. But if you have it as a shameful secret, you're fucked; you're sitting in a room populated by elephants. I have a lot of elephants to kill." Carrie was frank and open about her drug addiction and struggles with mental illness, writing a version of her story in her novel *Postcards from the Edge* (1987), which was later turned into a film, and in her 2008 memoir, *Wishful Drinking*, which was based on her one-woman stage show.

That level of openness could be hard for a child. But Billie learned from her grandma that she could ask her mom to "tone it down," and her mom would—Carrie knew what it was to grow up with a famous parent and how that weight fell on you. Carrie also taught her daughter the importance of authenticity: "Now, looking back and watching her interviews, I try to model what I do after her," Billie has said. "She was so good at it. She would get so annoyed with me if I ever did a fake interview. She'd say, 'Tell the real story.'"

At her mom's urging, Billie agreed to a small role in *Star Wars: The Force Awakens*, working next to the iconic Leia. "The thing is, I was bizarrely

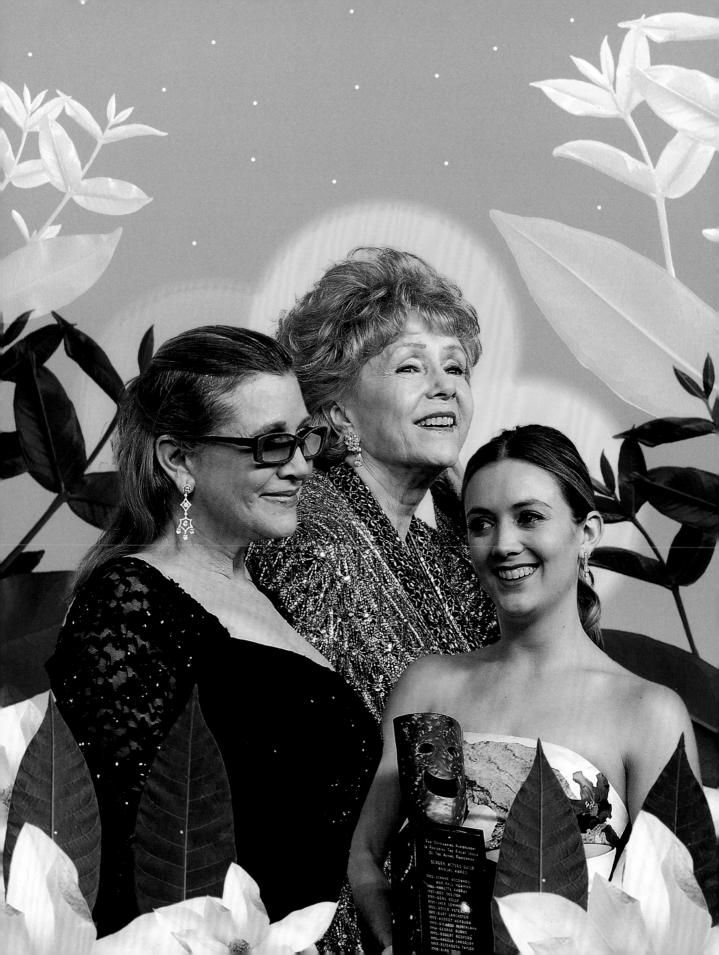

comfortable on set," Billie said. "My mother would pull me aside and be like, 'It's weird that you're so comfortable here. This is the most uncomfortable environment in the world. If you're comfortable here, you should do this.'" Her grandma encouraged her too: Billie remembered that even three days before she died, Debbie was asking her what dancing numbers or impersonations Billie was preparing for her "act." "I said, 'I don't think people do acts as much anymore!'" (Debbie was sure that if it was such a "dying art," having one would only make Billie stand out more.)

Billie looks a lot like her grandmother as a young woman, but with the raspier voice and biting humor of her mom. In the wake of losing two matriarchs, she has become the keeper of both their legacies, all while looking for her own way forward. "I've always kind of lived in their shadows, and now is the first time in my life when I get to own my life and stand on my own," she said. "I love being my mother's daughter, and it's something I always will be, but now I get to be just Billie."

I KNEW SHE WOULD
BE SOMETHING BIG

Diana Jiménez Medina & Salma Hayek Pinault

When Salma Hayek Pinault was six years old, she saw something that changed her life. "I went to see *Willy Wonka and the Chocolate Factory*," she told *Hola! USA* in 2017, "and it wasn't that I said, 'I want to be an actress,' but rather, 'There is a world where anything is possible. There can be a chocolate river. There are no limitations.' And that's how I fell in love with film."

She was born Salma Valgarma Hayek Jiménez in 1966, in the town of Coatzacoalcos in Veracruz, Mexico. Her parents are Diana Jiménez, a Mexican opera singer of Spanish descent, and Sami Hayek Domínguez, a Lebanese Mexican businessman. "[My mom] has the most beautiful voice, she sings like an angel," Salma told *Hola!* in the cover story she shared with her mother. "My mother taught me that whenever she felt like singing, it didn't matter what anyone thought, including me. She was just gonna sing, and feel free with her voice. I love her for being brave, and having such an important voice in my life."

Could she have followed in her mom's footsteps to the stage, as a singer if not an opera star? Salma's fans might immediately think of her sensual crooning to acoustic guitar in *Desperado* (1995)—right before Antonio Banderas's El Mariachi shoves her off the bed to save her from a would-be assassin's gunfire.

Not a chance, according to Salma. "If you take the camera away and put me in front of an

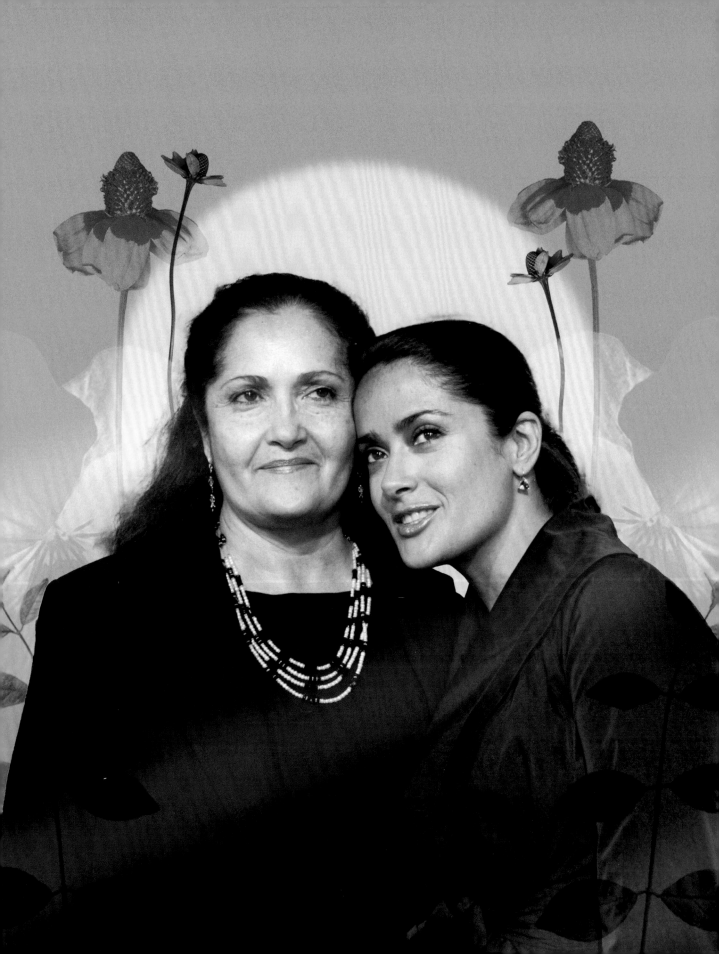

audience, I just die," she revealed in the interview with *Hola!* "I suffer from stage fright. No one would know it, but I get it really, really bad," she explained.

That was OK, according to Diana. "I always knew that Salmita would be something big in her life," she told the magazine. "Her personality, her way of always working for what she wants," she said, make her "unstoppable." After *Desperado*, Salma had a jaw-dropping cameo as a vampire in *From Dusk Till Dawn* in 1996, stole hearts in 1997's *Fools Rush In*, and was nominated for an Oscar for her role as artist Frida Kahlo in *Frida* (2002). More recently, she's starring in comedies, including *Like a Boss* (2020), and action flicks like Marvel's *Eternals* (2021).

Diana and Salma are very close today, and it's an intimacy that Salma brings to her relationship with her own daughter, Valentina Paloma Pinault.

On becoming a mom late in life (she was over forty when she had Valentina), she told *American Baby* in 2008: "People always say about having a child, 'You've never loved anyone so much. It's like nothing you've ever felt.'" She says she reacted analytically—yes, of course, she'd love her child. "But unless you experience it, you cannot understand what they're talking about."

More recently, she's enjoying finding out who her daughter is as a person and letting Valentina see the inner workings of her mom's job in Hollywood, bringing her along to sets and photo shoots. "[While we] are not very similar personality-wise," Salma said in 2017, they're similar in other ways. "Valentina and I are the ones who panic on stage, but she gets in front of the camera with no problem!" With an "unstoppable" mom and doting grandma, Valentina might just be the next to be destined for greatness.

WEATHERING THE STORM, TOGETHER

May May Miller (Ci Zhang) & Chanel Miller

Today, you know her name: Chanel Miller. Before she chose to reveal it to the world via the *New York Times* upon the release of her 2019 memoir, *Know My Name*, the world had called her "Emily Doe." That comes later, though.

To her family, she has always been Chanel—older sister to Tiffany, daughter to her dad and her mom, writer and filmmaker May May Miller. Chanel was born and raised in Palo Alto, California, and is now an artist, author, and activist living in New York. As a kid, she told the *Los Angeles Times* in 2020, she would draw for hours. May May would frame her daughter's pieces and hang them over the fireplace. Chanel says it gave her a "sense of legitimacy" about her art practice from a young age, and since then it's been the way

she best expresses herself. Her Instagram is full of scenes featuring her loopy-lined self-portrait, her processing of current events, and her musings on mental and emotional health.

In April 2020, Chanel debuted her 70-foot-long vinyl mural in a new addition at the San Francisco Museum of Modern Art. *I Was, I Am, I Will Be* shows a figure in a series of vignettes: curled in a fetal position in a pool of tears; sitting cross-legged, eyes closed in glowing meditation; standing and walking away. It's a work that recognizes the cycle of pain and trauma, healing, and moving forward.

This process is something that May May, Chanel's mom, explored in her personal documentary, *The Faith in Ailao Mountain* (2014). She

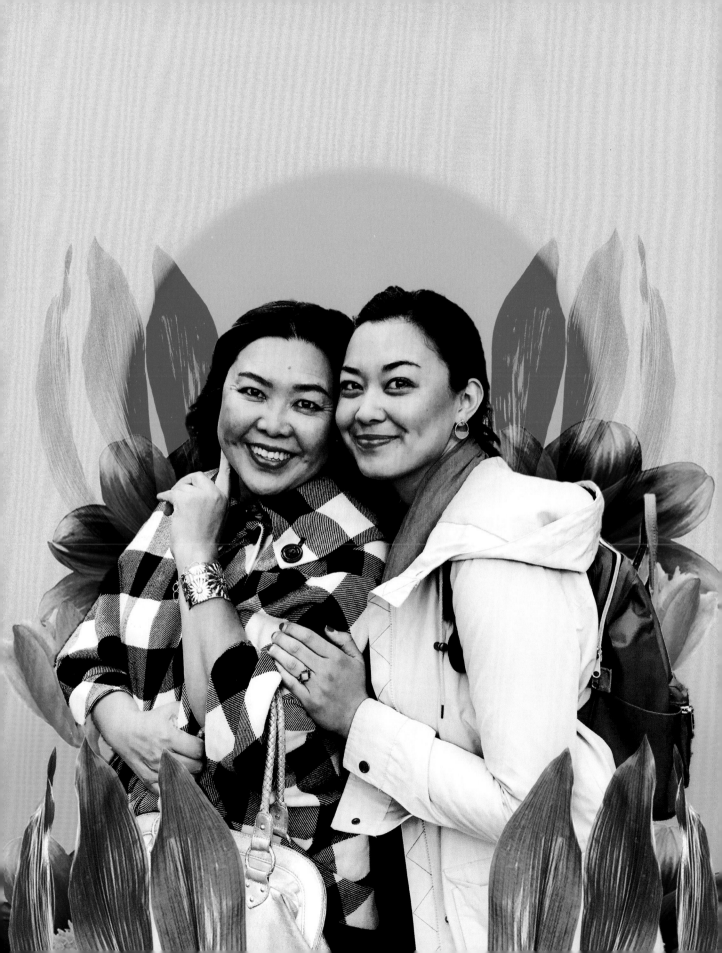

was born May May Ci Zhang in China's Yunnan Province and emigrated to San Francisco in the 1980s for a life outside the Communist country. When her mother became ill, she returned to her impoverished childhood home and recorded her mother's struggles with her health. The film was a way to revisit her painful relationship with her motherland and with her mother. For Chanel and her sister, their mom's history and the challenges she overcame as an immigrant showed them what resilience looks like. Chanel, and her family, couldn't have imagined the way that resilience would be tested.

In 2015, Chanel was called Emily Doe by the media and in court documents to protect her identity. On January 17 of that year, passersby on the Stanford University campus chased away and caught a man, identified as Brock Turner, whom they'd seen raping an unconscious woman in an alleyway. In court, Emily Doe's powerful words to her attacker about her experience captivated the world; her statement was even read by US representative Jackie Speier on the House floor in 2016. Brock Turner was convicted but only sentenced to six months in prison because the judge didn't think his crimes should ruin the young aspiring swimmer's career. He served just three months. The public was outraged, and Judge Aaron Persky was the first California judge to be recalled in over eighty years.

After the assault, Chanel wrote in her memoir, she initially didn't tell her parents. When she finally did, she remembers breaking down at the family dining room table. "I heard the chair scrape the wood as my mom pushed away from the table, springing up, immediate. . . . She held on to me tightly, one arm locked firmly around my side, the other hand stroking my hair. Whispering *Mommy's not mad, mommy's just scared.*"

The comfort of her mom's touch and her parents' offerings of her favorite dishes (including a lemon pie her dad left outside her room that evening) were small but potent reminders in those early days that she didn't need to carry her trauma alone. "The people who love you want to suffer with you," Chanel told the *New York Times*. "I spent so much energy trying to protect them from everything, when the whole time, they really did just want to be beside me, weathering the storm."

Acknowledgments

Thank you to Bridget Watson-Payne at Chronicle Books for trusting me with this book. Thanks to Mirabelle Korn for shepherding production, to Allison Weiner for your beautiful cover and layout, and the rest of the talented team at Chronicle for putting yet another stunner on the shelf.

Huge thanks to the amazing Natasha Cunningham for the gorgeous one-of-a-kind collage portraits for the women in this book. Your skill and your grace are beyond measure!

Thanks to Amy Levenson of Blue Heron Literary for your endless support and encouragement.

Thanks to Chanel Miller for contributing the lovely photo of you and your mom.

Thank you to Sonnet Fitzgerald and Felix Fitzgerald for your brilliant suggestions and tender insights that made this book stronger.

Thank you to my mama, Sue, to whom this book is dedicated. How we love you! Thanks to my sisters, Jessica, Sarah, and Hannah, and my sisters-in-law, Zoe and Chelsea—you are amazing mothers all to your babies, kiddos, and/or critters. Special thanks to my ever-supportive mother-in-law Leah for reading everything. And thanks, as always, to my love, Tyler.

Sources

CHAPTER 1

Diana Ross & Tracee Ellis Ross:

Cooney, Jenny. "Diana's Dynamo Daughter Tracee Ellis Ross on Finding Her Voice as a Diva." *Sydney Morning Herald*, September 12, 2020. https://www.smh.com.au/culture/movies/diana-s-dynamo-daughter-tracee-ellis-ross-on-finding-her-voice-as-a-diva-20200909-p55ttp.html.

Hirschberg, Lynn. "Tracee Ellis Ross Has Definitive Proof That Diana Ross Is the Greatest Mom of All Time." *W* magazine, September 7, 2017. https://www.wmagazine.com/story/tracee-ellis-ross-black-ish-emmys-diana-ross/.

Majewski, Lori. "Tracee Ellis Ross Has Confidence Advice That Will Rock Your World." *Good Housekeeping*, April 11, 2017. https://www.goodhousekeeping.com/life/entertainment/a43610/tracee-ellis-ross-cover-story/.

Ryan, Patrick. "Tracee Ellis Ross Recalls 'Very Special' Moment with Mom Diana Ross While Making 'The High Note'." *USA Today*, May 29, 2020. https://www.usatoday.com/story/entertainment/movies/2020/05/29/tracee-ellis-ross-talks-high-note-diana-ross-quarantine-joy/5272065002/.

Alice Waters & Fanny Singer:

Klauer, Brooke. "A Conversation with Fanny Singer About Her Mother-Daughter Memoir, *Always Home*." *The Fold*, May 7, 2020. https://thefoldmag.com/arts-culture/a-conversation-with-fanny-singer-about-her-mother-daughter-memoir-always-home.

Singer, Fanny, and Alice Waters. *Always Home: A Daughter's Recipes & Stories*. New York: Knopf, 2020.

Wolk, Martin. "Cooking in Quarantine: 'Always Home' Author Fanny Singer Retreats to Alice Waters' Kitchen." *Los Angeles Times*, April 14, 2020. https://www.latimes.com/entertainment-arts/books/story/2020-04-14/fanny-singer-always-home-alice-waters-recipes.

Lisa Bonet & Zoë Kravitz:

Byrd, Ayana. "Pirate Woman," *Honey Magazine*, Issue 1, 1999. http://www.geocities.ws/liliquoimoon/honey.html Devaney, Susan. "Like Mother, Like Daughter, Zoë Kravitz Has Always Been Here For

'Fashun'." *Vogue UK*, September 11, 2020. https://www.vogue.co.uk/news/article/zoe-kravitz-throw-back-lisa-bonet-fashion#intcid=_vogue-uk_d29cf175-4bb7-43e4-862b-a2542d0f62ce_similar2-3.

Osei, Sarah. "Zoë Kravitz's 'High Fidelity' Remake Just Aired & Twitter Is Already Obsessed." *HighSnobiety*, March 2020. https://www.highsnobiety.com/p/high-fidelity-zoe-kravitz-reactions/.

Porter Editors. "A Big Little Life: With Zoë Kravitz." *Porter*, June 15, 2017. https://www.net-a-porter.com/en-gb/porter/article-cadba9c78825f3af/cover-stories/cover-stories/zoe-kravitz.

Porter Editors. "A Life Less Ordinary: With Lisa Bonet." *Porter*, March 9, 2018. https://www.net-a-porter.com/en-us/porter/article-33a55e73f6c7ac7b/cover-stories/cover-stories/lisa-bonet?cm_mmc=LinkshareUS-_-TnL5HPStwNw-_-Custom-_-LinkBuilder&ranMID=24449&ranEAID=TnL5HPStwNw&ranSiteID=TnL5HPStwNw-KtSB7ORwzh.Kz8eokZ3MUQ&siteID=TnL5HPStwNw-KtSB7ORwzh.Kz8eokZ3MUQ.

Specter, Emma. "The Zoë Kravitz Reboot of *High Fidelity* Has One Flaw." *Vogue*, February 19, 2020. https://www.vogue.com/article/high-fidelity-zoe-kravitz-2020.

Audrey Hepburn & Emma Kathleen Hepburn Ferrer:

Fiori, Pamela. "Emma Ferrer Opens Up." *Harper's Bazaar*, August 12, 2014. https://www.harpersbazaar.com/culture/features/a3125/emma-ferrer-audrey-hepburn-interview-0914/#slide-1.

McNeil, Liz. "Why Audrey Hepburn Refused to Have Her Wrinkles Photoshopped." *People*, August 24, 2017. https://people.com/movies/why-audrey-hepburn-refused-to-have-her-wrinkles-photoshopped/.

Betye Saar, Alison Saar & Lezley Saar:

Cheng, Scarlet. "Mothers, Daughters, Memories." *Los Angeles Times*, May 30, 2006. https://www.latimes.com/archives/la-xpm-2006-may-30-et-saar30-story.html.

Cotter, Holland. "'It's About Time!' Betye Saar's Long Climb to the Summit." *New York Times*, September 4, 2019. https://www.nytimes.com/2019/09/04/arts/design/betye-saar.html.

Pagel, David. "Review: Yassa, Septime, Burvis. Meet the Magical Women of Lezley Saar's world." *Los Angeles Times*, February 5, 2020. https://www.latimes.com/entertainment-arts/story/2020-02-05/lezley-saar-walter-maciel-review.

Saar, Betye. "Influences: Betye Saar." *Frieze* magazine, September 27, 2016. https://www.frieze.com/article/influences-betye-saar.

Stamberg, Susan. "'She's Challenging You': Alison Saar's Sculptures Speak to Race, Beauty, Power." *Morning Edition*, NPR, May 12, 2020 https://www.npr.org/2020/05/12/851769833/she-s-challenging-you-alison-saar-s-sculptures-speak-to-race-beauty-power.

CHAPTER 2

Minnie Riperton & Maya Rudolph:

Marotta, Jenna. "Maya Rudolph on Her Prince Cover Band and Mourning the Purple One." *The Cut*, September 27, 2016. https://www.thecut.com/2016/09/maya-rudolph-on-princess-her-prince-cover-band.html.

uDiscover Team. "Maya Rudolph on Her Mother's Iconic Album, 'Perfect Angel,' and Legacy." uDiscover Music, August 9, 2019. https://www.udiscovermusic.com/stories/maya-rudolph-on-her-mother-minnie-riperton/.

Weaver, Caity. "How Maya Rudolph Became the Master of Impressions." *New York Times Magazine*, September 14, 2018. https://www.nytimes.com/2018/09/14/magazine/maya-rudolph-snl-amazon-forever.html.

Ingrid Bergman & Isabella Rossellini:

Regensdorf, Laura. "Isabella Rossellini on Aging with Confidence—and 6 Wise Rules for a Beautiful Life." *Vogue*, April 18, 2018. https://www.vogue.com/article/isabella-rossellini-interview-lancome-65-beauty-icon-skin-care-aging.

Sagal, Peter. "Not My Job: We Quiz Actor, Filmmaker Isabella Rossellini on Taco Bell(a)." *Wait, Wait... Don't Tell Me*, NPR, August 15, 2020. https://www.npr.org/2020/08/15/902593186/not-my-job-we-quiz-actor-filmmaker-isabella-rossellini-on-taco-bell-a.

Sayej, Nadja. "Isabella Rossellini on Her Mother Ingrid Bergman's Enduring Style." *T Magazine*, August 6, 2015. https://tmagazine.blogs.nytimes.com/2015/08/06/isabella-rossellini-on-ingrid-bergman.

Phoebe Ephron & Nora Ephron (with Delia, Hallie & Amy Ephron):

David Letterman. Excerpted in *Everything is Copy—Nora Ephron: Scripted & Unscripted*. Directed by Jacob Bernstein and Nick Hooker. HBO, 2015. https://www.hbomax.com/feature/urn:hbo:feature:GVqFz1Q1zlsPDPcYIAAAH

Ephron, Hallie. "Coming of Age with the Ephron Sisters—and Their Mother." *O, The Oprah Magazine*, March 2013. http://www.oprah.com/spirit/nora-ephrons-mother-hallie-ephron-essay/all#ixzz6SIKpNI2u.

Kilian, Michael. "Writers Bloc." *Chicago Tribune*, July 19, 2000. https://www.chicagotribune.com/news/ct-xpm-2000-07-19-0007190050-story.html.

Morning Edition, NPR. "'I Remember Nothing': Nora Ephron, Aging Gratefully." *Morning Edition*, NPR November 9, 2010. https://www.npr.org/templates/story/story.php?storyId=131161208.

Thérèse Dion & Celine Dion:

Basem, Boshra, and Amy Luft. "'Maman, We Love You So Much': Thérèse Dion, Mother of Superstar Celine Dion, Has Died at Age 92." CTV News, January 17, 2020. https://montreal.ctvnews.ca/maman-we-love-you-so-much-therese-dion-mother-of-superstar-celine-dion-has-died-at-age-92-1.4771982.

CNA Editors. "The Power of Love: A S$30.96 Million Celine Dion Biopic in the Works." Channel News Asia, January 31, 2019. https://cnalifestyle.channelnewsasia.com/trending/power-of-love-celine-dion-biopic-titanic-think-twice-11189244.

Kelly, Brendan. "Maman Dion was 'the Mother of All of Quebec'." *Montreal Gazette*, January 18, 2020. https://montrealgazette.com/news/local-news/maman-dion-was-the-mother-of-all-of-quebec.

CHAPTER 3

Peggy Lipton & Rashida Jones:

Brockes, Emma. "Rashida Jones: 'I didn't know if I was coming or going'." *The Guardian*, October 2, 2020. https://www.theguardian.com/film/2020/oct/02/rashida-jones-i-didnt-know-if-i-was-coming-or-going.

Jones, Rashida, and Suzan Colón. "Rashida Jones' Aha! Moment." *O, The Oprah Magazine*, April 2009. https://www.oprah.com/world/rashida-jones-aha-moment-on-her-mom-peggy-lipton-and-cancer.

King, Susan. "The Lipton Plunge: Thoroughly 'Mod' Actress Dives into CBS Series 'Angel Falls,'" *Los Angeles Times*, September 5, 1993. https://www.latimes.com/archives/la-xpm-1993-09-05-tv-31817-story.html

Saldiva, Gabriela. "Peggy Lipton, Star of 'The Mod Squad' and 'Twin Peaks,' Dies at 72." *NPR*, May 12, 2019. https://www.npr.org/2019/05/12/722590154/peggy-lipton-star-of-the-mod-squad-and-twin-peaks-dies-at-72.

Tina Knowles-Lawson, Solange Knowles, & Beyoncé Knowles-Carter:

Beyoncé. "Solange Brings It All Full Circle with Her Sister Beyoncé." *Interview*, January 10, 2017. https://www.interviewmagazine.com/music/solange#_.

Drew, Kimberly. "Tina Knowles Lawson on Her Black Art Collection, Beyoncé, Solange, and Creativity." *Vanity Fair*, August 6, 2018. https://www.vanityfair.com/style/2018/08/tina-knowles-lawson-black-art-collection-beyonce-solange-creativity.

Hawgood, Alex. "The Matriarch Behind Beyoncé and Solange." *New York Times*, January 21, 2017. https://www.nytimes.com/2017/01/21/fashion/tina-knowles-lawson-beyonce-solange-matriarch.html.

Marine, Brooke. "Tina Knowles-Lawson Was Told Destiny's Child's Outfits Were 'Too Black,'" *W*, August 5, 2020. https://www.wmagazine.com/story/tina-knowles-lawson-destinys-child-outfits-style

Mayo, Kierna. "Tina Knowles Lawson Exclusive." *Ebony*, June 15, 2015. https://www.ebony.com/entertainment/cover-story-tina-knowles-lawson-exclusive-987/.

Terri Irwin & Bindi Irwin:

Courier Mail Staff. "Mess on His Wedding Day." *The Courier Mail*, September 8, 2006. www.couriermail.com.au/news/mess-on-his-wedding-day/news-story/5a82d374b7938403c51f950baf6ebe54?sv=eocaf163b4623008ba161932d77a5f0e.

Kay, Lauren. "Bindi Irwin on Pregnancy, Baby Names and Carrying on Her Father's Legacy," *The Bump*, February 2021. https://www.thebump.com/a/bindi-irwin-qa-the-bump

Kennedy, William. "Before They Were Stars: Eugene Natives Represent Their Hometown on a National Scale." *Eugene Magazine*. Accessed March 10, 2021. https://eugenemagazine.com/feature-stories/before-they-were-stars/.

Keogh, Joey. "The Heartbreaking Marriage Advice Bindi Irwin Got from Her Mom." *The List*, February 20, 2020. https://www.thelist.com/189706/the-heartbreaking-marriage-advice-bindi-irwin-got-from-her-mom/.

Oracene Price, Venus Williams & Serena Williams:

Azoulay, Bonnie. "Venus Williams Opens Up About Fighting for Equal Pay for Women at Wimbledon," *SheKnows*, June 26, 2020. https://www.sheknows.com/entertainment/articles/2279742/venus-williams-equal-pay-wimbledon/.

Breen, Kerry. "Mom of Venus and Serena Williams Shares the Secrets of Raising Superstars." *Today*, August 21, 2019. https://www.today.com/parents/mom-venus-serena-williams-raising-superstars-t161084.

Ebony Staff. "Serena and Venus on the Fabulous Oracene, Mother of the Williams Dynasty." *Ebony*, May 2003. Accessed via Google Books, March 10, 2021. https://books.google.com/books?id=GtYDAAAAMBAJ&pg=PA166&lpg=PA166&dq=tina+knowles+hair+salon&source=bl&ots=fPWl3bMwKl&sig=6F_NZcwVcAIuSD2gDxXO_vWTIkE&hl=en&sa=X&ei=8j8MVMWLH4moO5fYgOgF&redir_esc=y#v=onepage&q=tina%20knowles%20hair%20salon&f=false.

Kimmelman, Michael. "How Power Has Transformed Women's Tennis." *New York Times*, August 25, 2010. https://www.nytimes.com/2010/08/29/magazine/29Tennis-t.html.

Rafferty, Scott. "Serena Williams Thanks Mother for Being Role Model in Emotional Letter." *Rolling Stone*, September 20, 2017. https://www.rollingstone.com/culture/culture-sports/serena-williams-thanks-mother-for-being-role-model-in-emotional-letter-199462.

CHAPTER 4

Linda McCartney & Stella McCartney:

Borrelli-Persson, Laird. "Tracing Stella McCartney's Singular Sense of Style Back to Her Childhood." *Vogue*, March 6, 2016. https://www.vogue.com/article/stella-mccartney-personal-style-paul-mccartney.

Felsenthal, Julia. "Family Matters in Linda and Mary McCartney's Photographs at Gagosian." *Vogue*, November 18, 2015. https://www.vogue.com/article/linda-mary-mccartney-gagosian.

Far Out Staff. "Candid Images of Paul McCartney with His Camera Taken by His Wife Linda." *Far Out*, 2019. https://faroutmagazine.co.uk/paul-mccartney-photographs-taken-by-linda/.

Financial Times Staff. "Happy Snaps: Paul, Stella, and Mary McCartney Share Their Intimate Family Photo Album." *Financial Times*, September 18, 2019. https://www.ft.com/content/3186363a-d94f-11e9-8f9b-77216ebe1f17.

Friedman, Vanessa. "Stella McCartney Had a Question: 'Why on Earth Would You Be in Fashion?'." *New York Times*, October 8, 2020. https://www.nytimes.com/2020/10/08/style/stella-mccartney-manifesto.html.

Heawood, Sophie. "Stella McCartney: 'It's not like I'm here for an easy life,'" *Guardian*, July 7, 2019. https://www.theguardian.com/fashion/2019/jul/07/stella-mccartney-its-not-like-i-am-here-for-an-easy-life.

Lipsky-Karasz, Elisa. "Stella, Paul, and Mary on Linda McCartney." *Harper's Bazaar*, March 22, 2011. https://www.harpersbazaar.com/celebrity/latest/news/a692/linda-mccartney/.

Jane Birkin & Charlotte Gainsbourg:

Davis, Allison P. "A Film Retrospective Pays Tribute to the Chicest Mother-Daughter Duo." *The Cut*, January 29, 2016. https://www.thecut.com/2016/01/jane-birkin-film-retrospective.html.

Feinstein, Laura. "French Icon Charlotte Gainsbourg on Finding Success in Your Forties." *Harper's Bazaar*, November 28, 2017. https://www.harpersbazaar.com/culture/features/a13787115/charlotte-gainsbourg-new-album-rest-interview/.

Kennedy, Maeve. "'He was a great man. I was just pretty': Photos tell story of Jane and Serge." *The Guardian*, April 6, 2018. https://www.theguardian.com/culture/2018/apr/06/jane-birkin-serge-gainsbourg-great-man-just-pretty-photos-tell-story-exhibition.

Mahdawi, Arwa. "Charlotte Gainsbourg: 'Everything now is so politically correct. So boring'." *The Guardian*, October 26, 2019. https://www.theguardian.com/culture/2019/oct/26/charlotte-gainsbourg-everything-now-so-politically-correct-boring.

Richmond, Brittany. "In the Midst of #MeToo, Jane Birkin Revisits Her Relationship with Serge Gainsbourg." *Vice*, February 1, 2018. https://garage.vice.com/en_us/article/8xd4na/jane-birkin-serge-gainsbourg-metoo.

Zemler, Emily. "Vogue Meets Charlotte Gainsbourg." *Vogue*, November 5, 2017. https://www.vogue.co.uk/article/charlotte-gainsbourg-vogue-uk-interview.

Nina Simone & Lisa Simone Kelly:

Garbus, Liz, dir. *What Happened, Miss Simone?* Los Gatos, California: Netflix, 2015. https://www.netflix.com/title/70308063.

Martin, Michel. "Nina Simone's Daughter Says This Film Gets Her Mom's Story Straight." *All Things Considered*, NPR, February 14, 2016. https://www.npr.org/2016/02/14/466748089/nina-simones-daughter-says-this-film-gets-her-moms-story-straight.

Pape, Stephan. "Liz Garbus and Lisa Simone Kelly on *What Happened, Miss Simone?*" HeyUGuys, June 23, 2015. https://www.heyuguys.com/interview-liz-garbus-lisa-simone-kelly/.

Judy Garland & Liza Minnelli:

Lipsky-Karasz, Elisa. "Liza Minnelli's New York." *Harper's Bazaar*, February 17, 2011. https://www.harpersbazaar.com/celebrity/latest/news/a673/liza-minnelli-interview/.

Malkin, Mark. "Liza Minnelli Opens Up About Mom Judy Garland, Working with Fosse, and Going to Rehab." *Variety*, February 4, 2020. https://variety.com/2020/film/features/liza-minnelli-judy-garland-bob-fosse-rehab-1203490846/.

CHAPTER 5

Jada Pinkett Smith & Willow Smith (with Adrienne Banfield-Norris):

1A. "Jada Pinkett Smith Shares Secrets Of Motherhood." *1A*, NPR, May 15, 2018. https://www.npr.org/2018/05/15/611389568/jada-pinkett-smith-shares-the-secrets-of-motherhood.

Pinkett Smith, Jada, Willow Smith, and Adrienne Banfield-Norris. *Red Table Talk*. Season 1, episode 1, "Motherhood." May 7, 2018. https://www.facebook.com/538649879867825/videos/560356131030533.

Singh, Olivia. "Jada Pinkett Smith Realized She Needed to Change When Her Daughter, Willow, Told the Actress She Didn't Know Her." *Insider*, November 5, 2019. https://www.insider.com/jada-pinkett-willow-smith-didnt-know-her-interview-2019-11.

Jane Fonda & Mary Lawanna Williams:

Raga, Pippa. "Jane Fonda's Adopted Daughter Is an Activist Now, Too." *Distractify*, June 1, 2020. https://www.distractify.com/p/jane-fonda-daughter-black-panthers.

Williams, Mary. *The Lost Daughter*. New York: Blue Rider Press, 2013.

Winfrey, Oprah. "Mary Williams Was Invited to Live with Jane Fonda." OWN, April 9, 2013. https://www.youtube.com/watch?v=C8V7ViTwxno.

Sridevi Kapoor & Janhvi Kapoor:

Johar, Karan. "Janhvi Kapoor Talks About Life After Sridevi in Her First Ever Interview." *Vogue India*, May 30, 2018. https://www.vogue.in/magazine-story/janhvi-kapoor-on-sridevi-vogue-india-exclusive-interview-with-karan-johar/.

Saxena, Poonam. "Sridevi: The Rough Diamond Who Transformed into India's First Female Superstar." *Dawn*, February 26, 2018. https://www.dawn.com/news/1391756.

Vetticad, Anna MM. "Sridevi: A True Pan-Indian Superstar from Kollywood to Bollywood." Al Jazeera, February 26, 2018. https://www.aljazeera.com/opinions/2018/2/26/sridevi-a-true-pan-indian-superstar-from-kollywood-to-bollywood/.

Jeon Young-nam & Sandra Oh:

Acuna, Kirsten. "Golden Globe Winner Sandra Oh Thanked Her Parents in Korean and People Are Loving It." *Insider*, January 6, 2019. https://www.insider.com/golden-globes-sandra-oh-thanks-parents-2019-1.

Mackelden, Amy. "Sandra Oh Discusses Lack of Diversity on *Killing Eve* & Fighting for Her *Grey's Anatomy* Character," *Harper's Bazaar*, June 28, 2020. https://www.harpersbazaar.com/celebrity/latest/a32988428/sandra-oh-shonda-rhimes-greys-anatomy-diversity/.

The Ellen DeGeneres Show. Season 4, Episode 14. Aired September 21, 2006. https://www.youtube.com/watch?v=wKqW_zuoQo8&t=2s.

Frederick, Candice. "Sandra Oh Finds Her Power in *Killing Eve*." *Harper's Bazaar*, April 6, 2018. https://www.harpersbazaar.com/culture/film-tv/a19694670/sandra-oh-killing-eve-interview/.

Posner, Michael. "Sandra Oh's Doing Just Fine." *Globe and Mail*, May 12 2007; updated May 13, 2009. https://web.archive.org/web/20140605115721/https://www.theglobeandmail.com/arts/sandra-ohs-doing-just-fine/article962237/?page=all.

Wong, Curtis. "On 'Ellen,' Sandra Oh Reveals She Had to Explain 'SNL' to Her Parents." *Huffington Post*, April 3, 2019. https://www.huffpost.com/entry/ellen-degeneres-sandra-oh_n_5ca4b405e4b0ed0d780f5c18.

CHAPTER 6

Katy Schafer & Hunter Schafer:

Ball, Billy. "NCPW Q&A: Meet the Trans Youth Taking a Stand Against Gov. Pat McCrory and House Bill 2." *North Carolina Policy Watch*, April 26, 2016. http://www.ncpolicywatch.com/2016/04/25/ncpw-exclusive-meet-the-trans-youth-taking-a-stand-against-gov-pat-mccrory-and-house-bill-2/.

Clark, Jess. "Q&A: A NC Teen and Her Parents on The Transition From Male to Female." North Carolina Public Radio, May 11, 2016. https://www.wunc.org/post/qa-nc-teen-and-her-parents-transition-male-female.

Cusumano, Katherine. "Rising Model Hunter Schafer Is Fighting for the Future of Trans Individuals On and Off the Runway," W magazine, March 21, 2018. https://www.wmagazine.com/story/hunter-schafer-model-bathroom-bill.

D'Addario, Daniel. "Trans Superstar Hunter Schafer on Her Moment of 'Euphoria.'" *Variety*, June 21, 2019. https://variety.com/2019/tv/features/hunter-schafer-hbo-euphoria-1203248330/.

Dwyer, Kate. "From Transgender Activist to Runway Model." *New York Times*, May 30, 2018. https://www.nytimes.com/2018/05/30/style/hunter-schafer-transgender-activist-model.html.

Greenwood, Douglas. "*Euphoria*'s Jules Was Based on Hunter Schafer's Teen Years." *i-D*, February 24, 2020. https://i-d.vice.com/en_uk/article/xgq4wn/euphoria-jules-hunter-schafer-real-life.

Kilbane, Brennan. "Hunter Schafer: 'Trying to Feel Seen Has Been the Project of My Life.'" *Allure*, September 2020. https://www.allure.com/story/hunter-schafer-september-cover-interview.

Schama, Chloe. "*Euphoria*'s Breakout Star Hunter Schafer on Playing an Unprecedented Character." *Vogue*, June 28, 2019. https://www.vogue.com/article/hunter-schafer-euphoria-hbo-interview.

Sharma, Jeena. "Hunter Schafer: Leading the Charge for Femme Representation." *Paper*, June 13, 2019. https://www.papermag.com/hunter-schafer-euphoria-2638773269.html.

Debbie Reynolds, Carrie Fisher, & Billie Lourd:

Bloom, Alexis, dir. and Fisher Stevens, dir. *Bright Lights: Starring Carrie Fisher and Debbie Reynolds.* New York: HBO Documentary Films, 2017. https://www.hbo.com/documentaries/bright-lights-starring-carrie-fisher-and-debbie-reynolds.

Miller, Julie. "Inside Carrie Fisher's Difficult Upbringing with Famous Parents." *Vanity Fair*, December 27, 2016. https://www.vanityfair.com/style/2016/12/carrie-fisher-parents-debbie-reynolds-eddie-hollywood.

Paulson, Sarah. "Billie Lourd's New Life." *Town and Country*, August 1, 2017. https://www.townandcountrymag.com/leisure/arts-and-culture/a10363337/billie-lourd-interview-on-carrie-fisher-american-horror-story/.

Zacharek, Stephanie. "Debbie Reynolds and Carrie Fisher Lived a Mother-Daughter Story Unlike Any Other." *Time*, December 29, 2016. https://time.com/4619559/debbie-reynolds-carrie-fisher/.

Diana Jiménez Medina & Salma Hayek Pinault:

Hola! USA. "Salma Hayek on Being a Parent: 'What my mom taught me was very important to me, but my daughter needs the opposite.'" *Hola! USA*, May 3, 2017. https://us.hola.com/hola-en-ingles/201705038103/salma-hayek-mom-first-cover-hola-usa/.

Marti, Diana. "Salma Hayek Poses With Her Mother & Opens Up About Suffering from Stage Fright: 'I Get It Really, Really Bad.'" *E Online*, May 3, 2017. https://www.eonline.com/news/847974/salma-hayek-poses-with-her-mother-opens-up-about-suffering-from-stage-fright-i-get-it-really-really-bad.

Robinson, Tasha. "Salma Hayek on Motherhood." *American Baby*, July 16, 2008. https://www.parents.com/parenting/celebrity-parents/salma-hayek/.

"Salma Hayek: The Powerful Lesson My Mother Taught Me." *The Oprah Winfrey Show*, OWN, May 5, 2017. https://www.youtube.com/watch?v=BToQwe-Tx8U.

May May Miller (Ci Zhang) & Chanel Miller:

Astor, Maggie. "California Voters Remove Judge Aaron Persky, Who Gave a 6-Month Sentence for Sexual Assault." *New York Times*, June 6, 2018. https://www.nytimes.com/2018/06/06/us/politics/judge-persky-brock-turner-recall.html.

County of Santa Clara. Emily Doe Victim Impact Statement. https://www.sccgov.org/sites/da/newsroom/newsreleases/Documents/B-Turner%20VIS.pdf.

Miller, Chanel. *Know My Name*. New York: Viking, 2019.

O'Malley, Katie. "Chanel Miller Is Learning to Love Her Body Again, After Stanford Sexual Assault." *Elle UK*, November 18, 2019. https://www.elle.com/uk/life-and-culture/culture/a29736809/chanel-miller-know-my-name/.

Plummer, Todd. "Chanel Miller on Her Art Debut: I never thought I'd have so much space to be seen." *Los Angeles Times*, August 17, 2020. https://www.latimes.com/entertainment-arts/story/2020-08-17/chanel-miller-mural-asian-art-museum.

Photo Credits

CHAPTER 1

Like Mother, Like Daughter: Following in her footsteps and in her embrace

Page 15: Diana Ross & Tracee Ellis Ross: Dia Dipasupil/Staff/Getty Images. Page 18: Alice Waters & Fanny Singer: Dia Dipasupil/FilmMagic/Getty Images. Page 21: Lisa Bonet & Zoë Kravitz: MediaPunch Inc/Alamy Stock Photo. Page 26: Audrey Hepburn: Entertainment Pictures/Alamy Stock Photo; Emma Kathleen Hepburn Ferrer: dpa picture alliance/Alamy Stock Photo. Page 29: Betye Saar: MediaPunch Inc/Alamy Stock Photo; Alison Saar: NOLWEN CIFUENTES/*The New York Times*/Redux Pictures; Lezley Saar: Gary Coronado/*The Los Angeles Times*/Getty Images.

CHAPTER 2

Carry This with You: Mementos, lessons, and guiding principles from our mothers

Page 37: Minnie Riperton: Michael Ochs Archives/Stringer/Getty Images; Maya Rudolph: ZUMA Press, Inc./Alamy Stock Photo. Page 40: Ingrid Bergman & Isabella Rossellini: Reporters Associati & Archivi/Mondadori Portfolio Premium/Getty Images. Page 45: Phoebe Ephron: Courtesy Everett Collection; Nora Ephron: REUTERS/Alamy Stock Photo. Page 48: Thérèse Dion: Michel PONOMAREFF/PONOPRESSE/Gamma-Rapho/Getty Images; Celine Dion: Pictorial Press Ltd/Alamy Stock Photo.

CHAPTER 3

*Side by Side: Mothers and daughters as peers
and costars, best friends and biggest fans*

Page 54: Peggy Lipton & Rashida Jones: ZUMA Press, Inc./Alamy Stock Photo. Page 59: Tina Knowles-Lawson: MediaPunch Inc/Alamy Stock Photo; Solange Knowles: Courtesy Everett Collection; Beyoncé Knowles-Carter: Image Press Agency/Alamy Stock Photo. Page 62: Terri Irwin & Bindi Irwin: Image Press Agency/Alamy Stock

Photo. Page 67: Oracene Price: dpa picture alliance/Alamy Stock Photo; Venus Williams: PA Images/Alamy Stock Photo; Serena Williams: Leo Mason/Alamy Stock Photo.

CHAPTER 4

*To Thine Own Self: Reconciling your shadows
and finding the light of your own way*

Page 73: Linda McCartney: Gijsbert Hanekroot/Alamy Stock Photo; Stella McCartney: Aflo Co. Ltd./Alamy Stock Photo. Page 78: Jane Birkin & Charlotte Gainsbourg: Jean Baptiste Lacroix/WireImage/Getty Images. Page 83: Nina Simone: BNA Photographic/Alamy Stock Photo; Lisa Simone Kelly: @ Christopher Pledger/eyevine/Redux Pictures. Page 86: Judy Garland & Liza Minnelli: Courtesy Everett Collection.

CHAPTER 5

*Finding Connection: Achieving common ground
as family and empathy as humans*

Page 92: Jada Pinkett Smith & Willow Smith: Jim Spellman/WireImage/Getty Images. Page 96: Jane Fonda & Mary Lawanna Williams: Photo 2012 @ Jake Stangel. Page 98: Sridevi Kapoor: Matt Carr/Getty Images Entertainment/Getty Images; Janhvi Kapoor: SUJIT JAISWAL/AFP/Getty Images. Page 102: Jeon Young-nam & Sandra Oh: Christopher Polk/NBCUniversal/Getty Images.

CHAPTER 6

Forging a New Path: Supporting each other through life changes and new directions

Page 110: Katy Schafer & Hunter Schafer: Allen G Breed/AP/Shutterstock. Page 115: Debbie Reynolds, Carrie Fisher & Billie Lourd: UPI/Alamy Stock Photo. Page 118: Diana Jiménez Medina & Salma Hayek Pinault: REUTERS/Alamy Stock Photo. Page 121: May May Miller (Ci Zhang) & Chanel Miller: Courtesy Chanel Miller.